WHAT
MAKES
GREAT
ART

A Quintessence Book

First published in the UK in 2012

This edition first published in the UK in 2013
by Frances Lincoln Ltd.
74–77 White Lion Street
London N1 9PF
www.franceslincoln.com

ISBN: 978-0-7112-3507-6
QSS.WARW

This book was designed and produced by
Quintessence Editions Ltd.
230 City Road, London, EC1V 2TT

Editor	Becky Gee
Designer	Tom Howey
Editorial Director	Jane Laing
Publisher	Mark Fletcher

Colour separation by KHL Chromagraphics, Singapore
Printed by 1010 Printing International Limited, China

9 8 7 6 5 4 3 2 1

FRONT COVER:
Girl With a Pearl Earring (c.1665) Johannes Vermeer

BACK COVER:
Under the Wave, off Kanagawa (c.1829–33) Katsushika Hokusai

Andy Pankhurst
Lucinda Hawksley

WHAT MAKES GREAT ART

80 MASTERPIECES EXPLAINED

F

CONTENTS

EXPRESSION

BEAUTY

REALISM

FORM

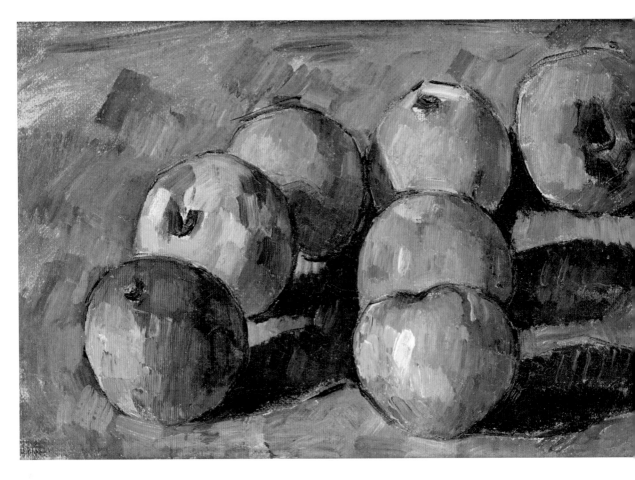

INTRODUCTION

Paul Cézanne famously claimed, "With an apple I will astonish Paris." These words were prophetic because more than 130 years later the French artist's still life paintings of apples continue to transfix viewers—but why? Why would viewers rather look at, and gain pleasure from, one of Cézanne's paintings than look at a real apple? What is it about some works of art that allows them to stand the test of time? What is it exactly that makes a work of art truly memorable and truly great?

There are many beautiful works of art and many more that are surprising, innovative, and thought provoking, but of all the art produced in the world in any given year, very few pieces are exceptional. "Great" art manages to satisfy its viewers at a deeper level than the rest, and *What Makes Great Art* looks at just what it is that makes an artwork a work of art. In this book, there is a selection of outstanding paintings and sculptures from around the world and from many centuries. The earliest examples chosen include Lascaux cave paintings, ancient Egyptian tomb paintings, early Campanian frescoes, ancient Greek sculptures, and ancient Roman mosaics; the most recent works include titles by Mark Rothko, Andy Warhol, and Bridget Riley.

The featured works have been looked at in an analytical manner in order to assess just what it is that makes each one so successful in its own field.

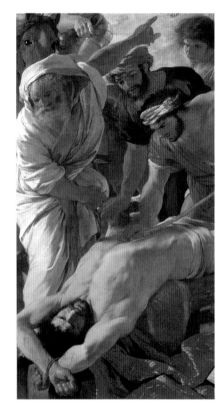

Those chosen include masterpieces of composition, such as Giotto di Bondone's *The Road to Calvary*; other paintings dazzle viewers with their use of color, such as Nicolas Poussin's *Martyrdom of St. Erasmus*. There are works that create an especially convincing sense of drama, for example Théodore Géricault's *The Raft of the Medusa*, and others that reveal a mastery of symbolism, as can be seen in Raphael's *The Mond Crucifixion*, or light—J. M. W. Turner's *Sun Setting Over a Lake*, or space—Alberto Giacometti's *Portrait of Annette*. Also featured are outstanding works of art that offer profound insights into political themes: works that still retain their original impact despite having been created in a previous century. These include Pablo Picasso's masterpiece *Guernica* and Francisco de Goya's *The Third of May, 1808*, both of which skillfully convey their desired message with great power.

What Makes Great Art has been divided into ten themed chapters: Expression, Beauty, Narrative, Drama, Erotic, Realism, Form, Movement, Distortion, and Symbolism. Each of these themes has been subdivided further: for example, in the Erotic chapter, Gianlorenzo Bernini's *The Ecstasy of St. Teresa* is explored in terms of metaphysics; Rembrandt van Rijn's *Self-Portrait at the Age of 63* features in the Realism chapter as a masterful study of form; and Vincent van Gogh's *Wheatfield With Crows* appears in the Expression chapter under the subheading

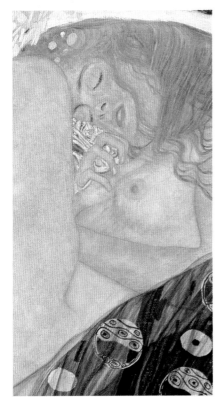

"Brushstrokes" because of the artist's superb use of both. The sections are not divided into art movements or subject matter; it is the essence of a work of art that determines its position in the book: for example the chapter on Symbolism analyzes paintings as diverse as Jacopo Tintoretto's *The Origin of the Milky Way*, Marc Chagall's *I and the Village*, and Barnett Newman's *Be I (Second Version)*. Artists featured in the chapter on Beauty are as varied as Leonardo da Vinci, Jean-Auguste-Dominique Ingres, and Claude Monet. Erotic art includes an ancient Hindu sculpture, a Japanese woodcut by Katsushika Hokusai, and a painting by the Austrian Secessionist Gustav Klimt.

What Makes Great Art invites viewers to look closely at the elements of each masterpiece, explore the particular concepts within each one, and discover what it is that makes an artwork so successful and what distinguishes it from its peers. Each entry will help viewers to understand what goes through the mind of an artist as they create what is, at that precise moment in time, the most important work of their career. Some of the techniques are used consciously and thought out in minute detail, yet there are others that happen serendipitously, imbuing a work with what is often seen as an indefinable sense of perfection.

This publication acknowledges that subjectivity will—and indeed must— always play a role in the appreciation of art. "Well, I don't know about art,

The Road to Calvary (c.1304–13)
Giotto di Bondone
▷▷ DRAMA p75

but I know what I like" is a remark that is often heard at galleries and museums, but it is as valid as the high-faluting claims made by professional art critics in the newspapers. Everyone can appreciate art—whether they feel "qualified" to do so or not. Equally, everyone can feel a sense of awe when standing before a great work of art: we can recognize that there is something magnificent about a certain work, and that feeling is universal because that is art's job. Art should appeal to the senses and make the viewer feel something, but that something is not always positive. Is it a bad thing when a reaction to a work of art is negative? Perhaps the only time a work of art does not do its job is when the viewer turns away with a bored shrug and forgets it within moments.

Art is not produced solely for intellectuals—quite the contrary. Giotto's paintings *The Road to Calvary* and *Lamentation of the Death of Christ* in the Cappella degli Scrovegni in Padua, Italy, which were made at the beginning of the fourteenth century, were created specifically for people who could not read but who could recognize and have empathy with stories that were told visually. Artists such as Giotto used their knowledge of image making to convince viewers of the verity of their creations. This is also true of cave dwellers as far back as c.14,000 BCE, whose images at Lascaux in France are so beautifully and precisely drawn that they support a belief in magic and spirits that would have

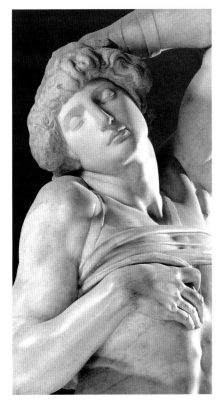

aided huntsmen in their quests. While working in the street in Florence, the great Renaissance artist Michelangelo is said to have changed a part of one of his sculptures in response to a comment from a passerby. When a man said that the hand looked wrong, the sculptor paused, looked at his work with new eyes, and then proceeded to change the hand as suggested by the layman in the street. A young Henry Moore heard this story at a Sunday school meeting, and it inspired him to become a sculptor. His *Recumbent Figure* in the Distortion chapter acknowledges the artist's debt to the Renaissance master: the figure is not depicted as one might expect, and although human veins are not actually visible, Michelangelo's "blood" runs through the stone.

By highlighting the essential conceptual and formal elements of the featured artworks—the ideas born within the artists themselves—we hope to unravel the mysteries of why certain works continue to hold such universal appeal for viewers today. Henri Matisse made the following claim for his works: "What I dream of is an art of balance, of purity and serenity, devoid of troubling or depressing subject matter, an art which could be for every mental worker, for the businessman as well as the man of letters, for example, a soothing, calming influence on the mind, something like a good armchair which provides relaxation from the physical fatigue." Matisse's comments have often been

dismissed or interpreted as shallow, but it must be remembered that, like Pablo Picasso, he lived through both world wars. The era in which an artist lived must always be taken into consideration when looking at their work from a twenty-first-century vantage point. For example, a landscape painted by an artist during a time when the world was in the chaos of war would have very different connotations to a landscape painted by an artist living during peace time.

It is also necessary to acknowledge the vagaries of fashion: many influential artists have always been ahead of their time, whereas others take their inspiration from a time that has long since past. If this book had been written a century ago, many of the nineteenth-century artists that are featured would not have made it into the final list. Certainly neither *The Man With the Puffy Face* nor *Wheatfield With Crows* by Vincent van Gogh would have been included during the artist's lifetime, yet today van Gogh is acknowledged as one of the world's greatest painters and Post-Impressionism as one of the most groundbreaking movements in the late nineteenth and early twentieth centuries. If a book such as this were to be written a century in the future, which of the featured works and artists would still be considered truly great?

Throughout *What Makes Great Art*, the various entries explain the possibilities and ideas of "the language of art," an abstract language that is

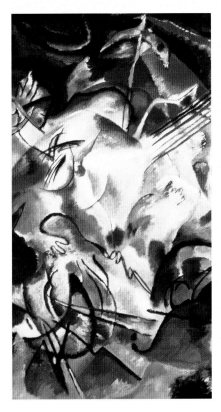

perceived by the visual senses, either through the two dimensions of a painting or drawing, such as Wassily Kandinsky's *Composition No. 6*, or through the three dimensions of sculpture, as seen *in Laocoön and His Sons* by Hagesandros, Athenodoros, and Polydorus. The US painter Jackson Pollock, whose *Mural* features in the Movement chapter, was one of the forerunners of Abstract Expressionism during the 1950s. He not only used his memory and imagination to make his paintings, but also studied Native American imagery and European Renaissance art. Pollock made drawings from his favorite works in order to gain an understanding of their particular laws of pictorial language. From this standpoint, he was then able to gain a pictorial freedom to make anew.

What Makes Great Art is for all those who want to discover more about what distinguishes good art from truly great art. The very title "What Makes Great Art" takes us away from the "everyday," providing moments to reflect, acknowledge, and transcend into the wondrous world of art, which can help us look toward the future and, possibly, at our relationship with the world itself.

Andy Pankhurst and Lucinda Hawksley

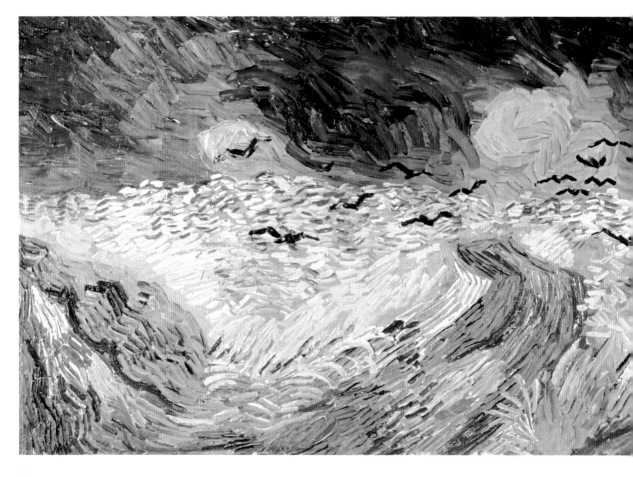

EXPRESSION

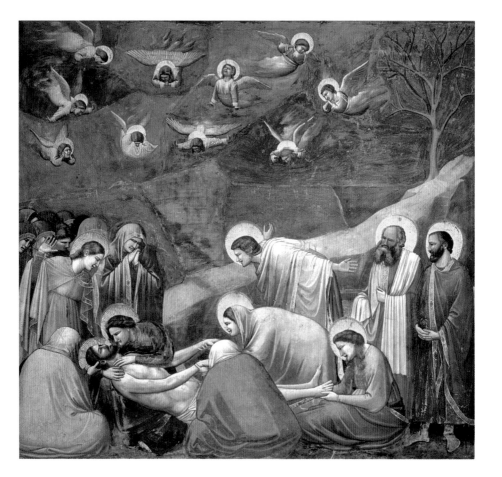

Lamentation of the Death of Christ *c.1304–13*
Giotto di Bondone

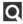

All gestural elements within this harrowing narrative work toward creating an overwhelming sensation of pain and sorrow. Behind Mary stand prominent figures assuming gestures of horror. St. John—central within the composition—leans forward with his arms thrust behind him in despair; even the ten angels in the sky echo the humans' lament. Giotto was not only an artist of genius, not only a man who would deliver art from the formulae of medieval and Byzantine tradition into the new world of realism, but also a real man who had lived, loved, and cried.

In *Lamentation of the Death of Christ*, Giotto di Bondone created, for the first time in the history of art, imagery imbued with true, natural humanity. He managed to express in paint genuine emotions, and this powerful image immediately focuses viewers' attention. A reclining figure, the dead body of Christ, is being held tenderly by surrounding mourners. His mother, Mary, cradles his upper torso like an infant, and her face portrays truly human suffering and anguish. At the top right of the painting are fresh green shoots of new life on an otherwise bare, solitary tree. These tentative signs from nature are the only elements in the scene that express hope and redemption.

Cimabue thought to hold the field in painting, and now Giotto hath the cry, so that the other's fame is growing dim."

Dante *Purgatory*

fresco
72¾ x 78¾ in (185 x 200 cm)
Capella degli Scrovegni,
Padua, Italy

The Last Supper (c.1308–11)
Duccio di Buoninsegna
Museo dell'Opera della
Metropolitana, Siena, Italy

Descent from the Cross (c.1435–40)
Rogier van der Weyden
Museo del Prado,
Madrid, Spain

Deposition from the Cross
(1525–28) **Pontormo**
Cappella Barbadori, Chiesa
di Santa Felicita, Florence, Italy

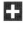

Crucifixion, from the Isenheim Altarpiece 1512–16
Mathis Grünewald

The focus of the scene is the body of Jesus, his limbs writhing in agony, his grasping hands indicative of extreme pain. His skin is scarred, foully blotched, and seemingly putrefying. The distortion of the crucifix is deliberate, so the elongated arms of the cross are able to frame the scene, encompassing Mary, St. John (the Apostle), and St. John the Baptist. St. Sebastian, patron saint of plagues, is the figure in the left-hand panel, his martyrdom by arrows painfully apparent. The altarpiece served to warn the hospital patients not to complain, that the suffering they were encountering was nothing compared to that which Jesus had endured for them, symbolized by the sacrificial lamb.

This was painted for the Monastery of St. Anthony in Alsace, France. On the right-hand panel is their patron saint, St Anthony the Hermit. Mathis Grünewald was aware that the people who would see his scene were largely the patients of the monastery hospital, many of whom were suffering from the plague. The altarpiece is truly gothic: the grotesque depictions of suffering, the painfully distorted limbs, the crudely constructed crucifix, and the religious message contained within.

> *I am poured out like water, and all my bones are disjointed; my heart is like wax melting within me. My strength is dried up like baked clay; my tongue sticks to the roof of my mouth. You put me into the dust of death."*
>
> **Psalm 22: 14–15**

oil on wood
106 x 120⁷⁄₈ in (269 x 307 cm)
Musée d'Unterlinden,
Colmar, France

The Rape of the Sabine Women
(c.1635–40)
Sir Peter Paul Rubens
National Gallery, London, UK

The Raft of the Medusa (1819)
Théodore Géricault
Musée du Louvre,
Paris, France

Guernica (1937)
Pablo Picasso
Museo Reina Sofía,
Madrid, Spain

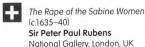

Sun Setting Over a Lake *c.*1840
J. M. W. Turner

Influenced by the romantic ideal of creating paintings that provoke an emotional response, in *Sun Setting Over a Lake* Turner urged the viewer to experience the "sublime"—a heightened crux of emotion felt by witnessing a miracle of nature: the perfect sunset. Despite positioning the setting sun toward the lower left corner of the canvas, Turner leads the viewer's eye toward it by painting in circular brushstrokes. The composition is deliberately obscure: an unspecified lake, perhaps surrounded by snow-capped mountains as seen through mist, indicated by swirling white paint.

 J. M. W. Turner's expressive style was achieved by using watercolor techniques in his oil paintings. In *Sun Setting Over a Lake* he places the sun itself in a vortex of intense color and changes the texture of the paint in different regions of that vortex. The warmth of the tones suggests the heat of the sun at its central point, soothed by the colder blues and whites at the top right of the canvas. Turner's loose brushstrokes and deliberately hazy topography often led to his canvases being derided as "unfinished." However, in the twentieth century his distinctive style was recognized as a crucial moment in the evolution of landscape painting, and he was a major influence on those who came after him, particularly the Impressionists.

If I could find anything blacker than black, I would use it."

J. M. W. Turner

oil on canvas
42 ⅛ x 54 ⅜ in (107 x 138 cm)
Tate Collection, London, UK

View of the Round-Top in the Catskill Mountains (1827)
Thomas Cole
Museum of Fine Art, Boston, USA

Impression: Sunrise (1872)
Claude Monet
Musée Marmottan,
Paris, France

Nocturne in Black and Gold: The Falling Rocket (c.1875)
James McNeill Whistler
Detroit Institute of Arts, USA

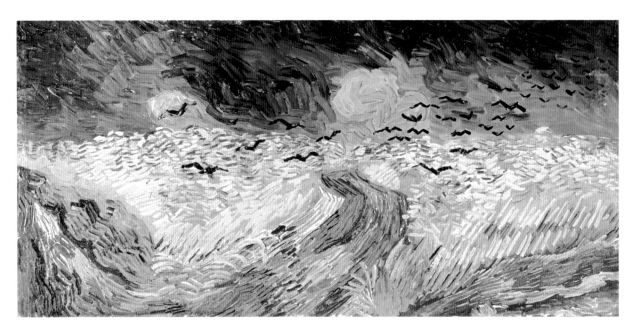

Wheat Field With Crows 1890
Vincent van Gogh

Van Gogh was a draftsman of great skill, and in this painting he expresses the essence of his subject and his own feelings with great clarity. He uses thick, powerful, thrusting brushstrokes, moving in streams and curves to animate the landscape and simple dabs of black paint to render the crows in flight. The dark blue and black stabbing brushstrokes of the sky descend in intense, dramatic waves toward the vibrant yellow of the cornfield. Although the painting is unsettling, it is the result of a highly intelligent, organized mind.

In *Wheat Field With Crows*, Vincent van Gogh uses brushstrokes and color—his primary forms of expression—to convey his emotional reaction to the natural world. He communicates his "sadness" and "loneliness," but he also celebrates his spiritual sense of wonder at nature's beauty—the intense blue sky set against the golden, yellow corn and the magical transitory moment of the startled crows. Anything that is not helping him to express these simple ideas is edited out. The painting is often said to have reflected van Gogh's emotional state, and aspects of the composition—the forbidding sky, the menacing crows, the three paths—are signs of foreboding and death.

> *Instead of trying to paint exactly what I see before me, I make more arbitrary use of color to express myself more forcefully."*
>
> **Vincent van Gogh**

oil on canvas
19⁷/₈ x 40 in (50.5 x 103 cm)
Van Gogh Museum,
Amsterdam, Netherlands

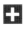

Ashes (1894)
Edvard Munch
Nasjonalgalleriet,
Oslo, Norway

The Unfortunate Land of Tyrol
(1913) **Franz Marc**
Solomon R. Guggenheim Museum,
New York, USA

Head of J. Y. M. (1973)
Frank Auerbach
Sheffield Galleries and Museum
Trust, Sheffield, UK

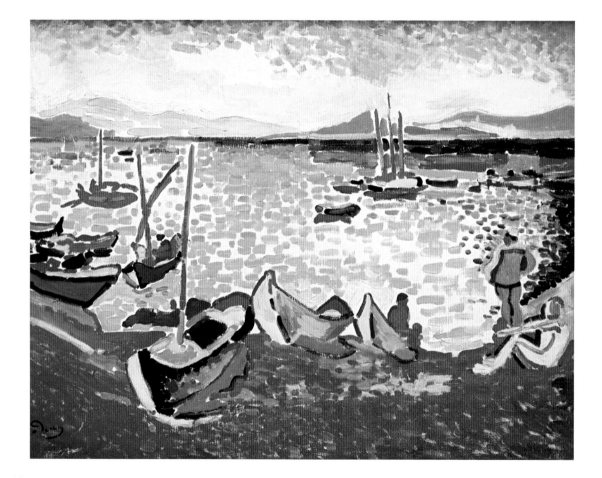

Boats in the Harbor at Collioure 1905
André Derain

When viewers look at this painting, they experience simultaneous contrasts, color values changing according to what they are next to: the yellow appears brighter against the blue than it does when next to the red. The golden sun beats down, raking across the scene; the cool green of the sea is in direct contrast to the beach. The sun reflects off the side of the boats, expressed with a saturated yellow. A contrasting dark blue and a green complementary to the beach represent the shadow of the foreground vessel. Look at the seated figure in profile to the right of picture; Derain has deliberately painted a dark blue line to heighten the luminosity.

In 1905, André Derain's friend and fellow painter Henri Matisse, who had been painting some six years earlier with a more saturated and brighter palette, asked Derain to spend the summer months in the Mediterranean village of Collioure in France. Derain was immediately struck by the light on the coast, and in *Boats in the Harbor at Collioure* he expressed what he both saw and felt. Using bold colors, Derain painted a vivid red beach, expressive of the heat and brightness of the sun, thus rejecting the preconceived idea of a yellow beach. The true local color of the fishing boats is not known because Derain used color to convey his perceived reality.

The shadow is a whole world of clarity and luminosity, which contrasts with the light of the sun—this is known as reflections."
André Derain

oil on canvas
15 x 18 in (38 x 46 cm)
Royal Academy of Arts,
London, UK

Blue Roofs (1901)
Pablo Picasso
Ashmolean Museum,
Oxford, UK

View of Collioure (1905)
Henri Matisse
State Hermitage Museum,
St. Petersburg, Russia

The Winkel Mill in Sunlight,
1908 (1908) **Piet Mondrian**
Gemeente museum den Haag,
The Hague, Netherlands

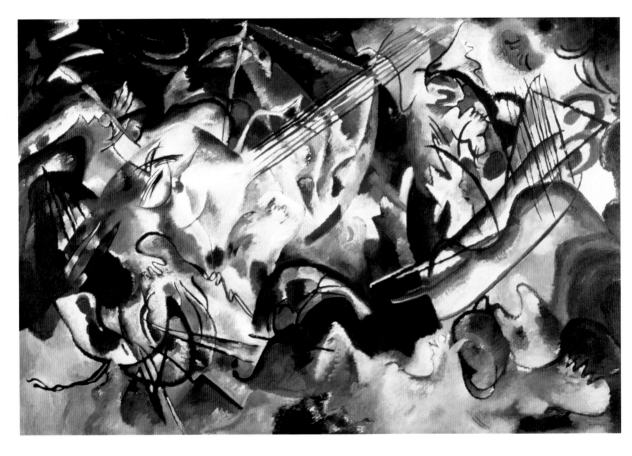

Composition No. 6 1913
Wassily Kandinsky

Kandinsky believed in "art for art's sake": that art need not have any other purpose except to nourish the soul. *Composition No. 6* (detail; left) is a lyrical, musical composition, with swirling colors and lines and no obvious narrative, perhaps indicative of the unrelated thoughts that swirl through a listener's mind when hearing music. Several of the lines suggest the strings or outlines of instruments. Kandinsky believed that the painter should be freed from the objective world in order to enter a lyrical world and be able to express inner feelings and emotions, similar to the way in which a musician plays music.

Wassily Kandinsky believed that the painter's expressive aim should be both a "melodic and symphonic" composition, combining purely abstract forms and color in order to produce a spiritual expression and well-being of the inner soul, or as Kandinsky put it himself, "the inner need." As a child he had expressed himself both musically and artistically. He was greatly affected by Richard Wagner's *Lohengrin* and had plans to become a musician. However, he was so inspired by Claude Monet's series *Haystacks* that he left home to study art in Munich.

> *Color is the keyboard, the eyes are the hammers, the soul is the piano with many strings. The artist is the hand which plays, touching one key or another, to cause vibrations in the soul."*
>
> **Wassily Kandinsky**

oil on canvas
76 3/4 x 118 1/8 in (195 x 300 cm)
State Hermitage Museum,
St. Petersburg, Russia

Nocturne: Blue and Gold—Old Battersea Bridge (c.1872–75)
James McNeill Whistler
Tate Britain, London, UK

Toward Evening (1909)
Gabriele Münter
Galerie Daniel Malingue,
Paris, France

Blue Horse II (1911)
Franz Marc
Private collection

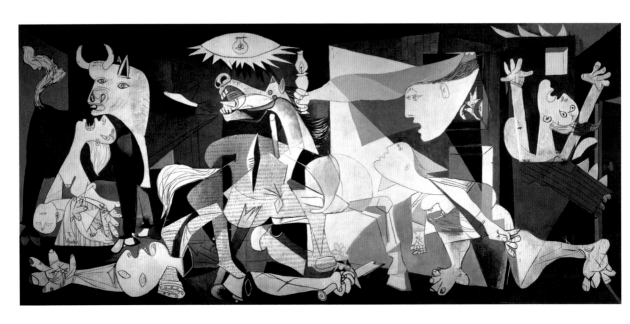

Guernica 1937
Pablo Picasso

On May 1, 1937, Picasso made the first small, frantic drawing studies for *Guernica*, which culminated five weeks later in the huge finished work that has become well known the world over—a universal icon and masterpiece of expression against the senseless horror of war. There has been endless discussion and description of Picasso's use of geometry, the distraught use of black, and the horrors the artist depicts by his deliberate creation of spiky, distorted shapes, yet the most dramatic thing about this painting is the history it portrays with such dynamic force: a history the artist wanted no one to forget.

In January 1937, Pablo Picasso, living in Paris, accepted a commission from the Spanish Republican government. It was for a painting to be ready for exhibition in July that same year, for the Spanish Pavilion at the Paris Exposition. For nearly four months Picasso contemplated ideas and subject matter, but the decision of what to paint was made for him when a horrifying news story broke. One Sunday afternoon, April 26, 1937, Nazi fighter pilots bombed the defenseless Basque town of Guernica, murdering and maiming nearly 3,000 innocent people. The news spread across Europe—and to Picasso in Paris.

A Gestapo officer holds a reproduction of Guernica *and asks Picasso, 'You did that, didn't you?' Picasso replies, 'No, you did.'*

From an interview with
Pablo Picasso

oil on canvas
137 3/8 x 305 in (349 x 776 cm)
Museo Reina Sofía,
Madrid, Spain

The Third of May, 1808 (1814)
Francisco de Goya
Museo del Prado,
Madrid, Spain

The Face of War (1940)
Salvador Dalí
Museum Boymans Van Beuningen,
Rotterdam, Netherlands

Being With (1946)
Roberto Matta
Metropolitan Museum of Art,
New York, USA

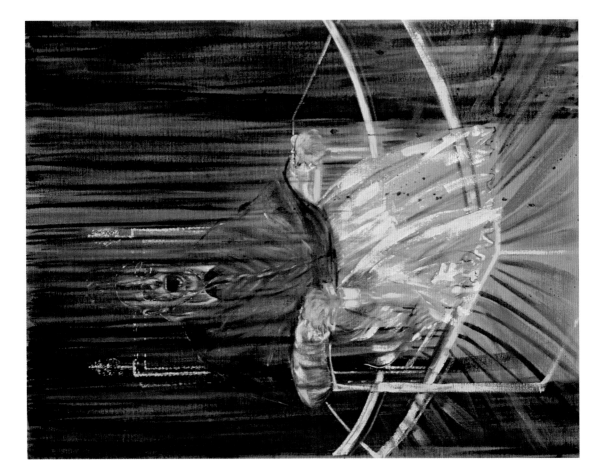

Study After Velázquez's Portrait of Pope Innocent X 1953 Francis Bacon

Bacon has replaced the all-powerful pope from Velázquez's painting with a pathetic, impotent figure whose exaggerated features intensify the nightmarish tone of the painting. The Pope's robes resemble a hospital gown, and he is screaming as his throne turns into an electric chair lit up by the force of a deadly electric shock. The diagonal lines at the bottom of the painting appear to absorb the electricity and force it upward and into the chair, while the vertical lines appear to shoot downward, forcing themselves into the figure and piercing his flesh, seeming at their most cruel and jagged as they enter his skull.

In 1650 Spanish artist Diego de Silva Velázquez produced his now iconic portrait *Pope Innocent X*. From the late 1940s onward, Francis Bacon made more than forty paintings and studies based on Velázquez's work. *Study After Velázquez's Portrait of Pope Innocent X* is a ghostly image nicknamed "the Screaming Pope." The exaggeration of the expression on the skull-like face, as well as the visually confusing distortion of the figure's surroundings, is an indictment of the horrors of medieval and modern religion intertwined. Bacon—brought up in a strict Catholic home—used Velázquez's work to take personal revenge on the religion that forced him to endure a cruel childhood filled with abuse and misery.

I should have been, I don't know, a con man, a robber, or a prostitute. But it was vanity that made me choose painting, vanity and chance."

Francis Bacon

oil on canvas
60 x 46 in (153 x 118 cm)
Des Moines Art Center,
Iowa, USA

The Scream (1893)
Edvard Munch
Nasjonalgalleriet,
Oslo, Norway

The Execution of Beloyannis
(1953) **Peter de Francia**
James Hyman Fine Art Gallery,
London, UK

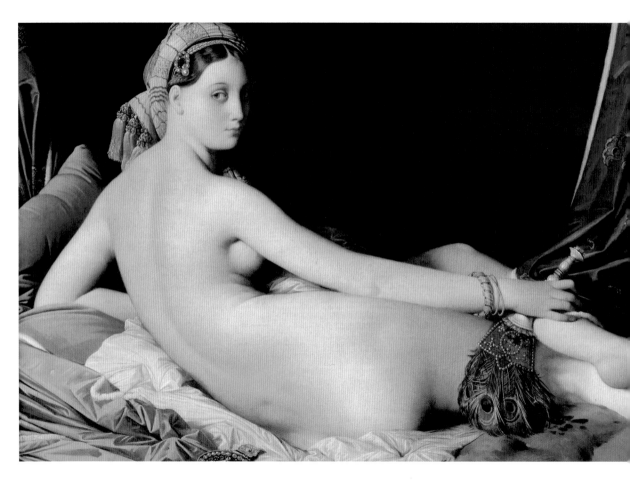

BEAUTY

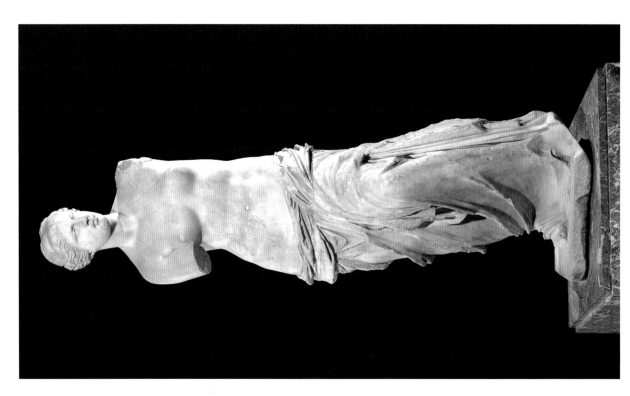

Venus de Milo c.130–100 BCE

Artist unknown

The style of Venus de Milo places it in the Hellenistic period, in which sculptures were created so that they would appear perfect from every angle. The face is proportioned to the Hellenistic ideal of beauty: the supposed perfect proportion for the female face was for it to be divided into three equal sections, with the nose forming exactly one-third of the length of the face. Sexual longing is expressed in the woman's parted thighs and twist in the hips, and the position of the hips also allows the statue to be interesting when viewed from different points.

The sheer beauty of the figure in this sculpture has led her to be identified as Venus (the Roman goddess of love and beauty whom the Greeks called Aphrodite), but no one knows her identity for certain. The "de Milo" in her name comes from her being found on the Aegean island of Milos. For many years, scholars believed that the ancient sculptors worked solely in smooth, white marble, but more recent research shows that statues such as this one would have been decorated: painted in bright colors and possibly adorned with jewels.

But what if man had eyes to see the true beauty— the divine beauty, pure and clear and unalloyed, not clogged with the pollutions of mortality and all the colors and vanities of human life—thither looking, and holding converse with the true beauty simple and divine?"

Plato *Symposium*

parian marble
79½ in (202 cm) high
Musée du Louvre,
Paris, France

Aphrodite of Cnidus (400BCE)
Praxiteles
Glyptothek, Munich, Germany

David (1504)
Michelangelo
Galleria dell'Accademia,
Florence, Italy

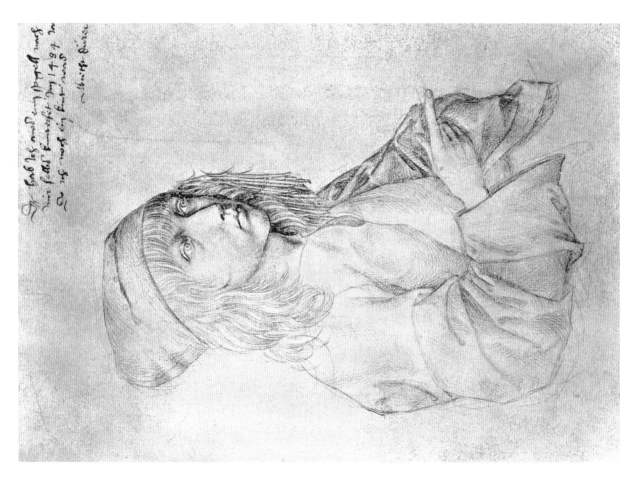

Self-Portrait at Thirteen 1484
Albrecht Dürer

Dürer created this silverpoint image by preparing the paper with a coat of white pigment, which he then drew upon with a thin rod of actual silver. This method produces a characteristic delicate and beautiful line and cannot be rubbed out: the artist had only one opportunity to create the perfect line. Dürer said of the work, "I drew this myself using a mirror in the year of 1484, when I was still a child." In later life, he went on to write treatises about such subjects as proportion, perspective, and human anatomy in art.

It is incredible to think that a boy of thirteen created one of the most beautiful images in the history of art. Viewers who compare Albrecht Dürer's image of his adolescent self with other self-portraits created throughout his career—both drawn and painted— would argue that no other is as beautiful, nor as perfect, as this one. The subject was not new: the depiction of a head, not even necessarily a portrait, has fascinated human beings from the earliest times, and images of human faces have been found within cave art dating back to c.15,000 BCE. However, there is a poignancy in Dürer's self-portrait that has seldom been matched.

*It is ordained
that never shall
any man be able,
out of his own
thoughts, to make
a beautiful figure,
unless, by much
study, he hath well
stored his mind."*

Albrecht Dürer

silver pen on grounded paper
Graphische Sammlung
Albertina, Vienna, Austria

Self-Portrait as a Young Man
(1628) **Rembrandt van Rijn**
Rijksmuseum, Amsterdam,
Netherlands

Man at Night (Self-Portrait)
(1948)
Lucian Freud
Private collection

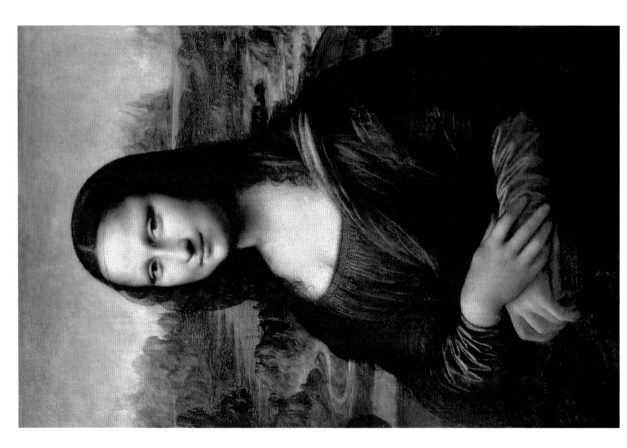

Mona Lisa 1503–06
Leonardo da Vinci

Leonardo da Vinci was a master of the new Renaissance technique of *sfumato*—a way of blending layers of dark and light paints that gives the finished painting a slightly mysterious, soft-focus look. This makes the viewer's eye work harder to adjust to the delicate tones of the painting—the effect is similar to the reaction of the eyes when looking at a person in dim lighting. Da Vinci deliberately used a subdued color palette, seemingly limited in range, yet he imbued his colors with an intensity and richness that suggests wealth and warmth.

Almost everyone who sees the *Mona Lisa* for the first time comments on how small it is—the mythology that has grown up around the painting leads viewers to expect a much larger, more imposing canvas. On first glance it is simply a representation of a beautiful woman—her clothing is subtle but exquisite and her hands are perfectly formed—yet behind the model there is also a complex and fascinating background. When looked at in terms of proportion, the face—the mischievous eyes and famous smile—should not be the focal point, positioned high as it is in the top third of the canvas, yet it is the face that draws in viewers.

As art may imitate nature, she does not appear to be painted, but truly of flesh and blood. On looking closely at the pit of her throat, one could swear that the pulses were beating."

Giorgio Vasari
The Lives of the Artists

oil on poplar
30⅜ x 20⅞ in (77 x 53 cm)
Musée du Louvre,
Paris, France

Girl With a Pearl Earring (1666)
Jan Vermeer
Mauritshuis, The Hague,
Netherlands

Portrait of a Lady in Blue (c.1777)
Thomas Gainsborough
State Hermitage Museum,
St. Petersburg, Russia

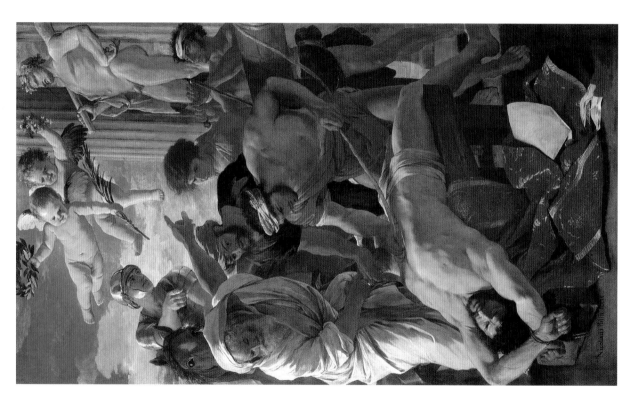

Martyrdom of St. Erasmus

1628–29 Nicolas Poussin

The viewer's first sensation upon seeing this masterful painting is of how beautiful it is. The experience of what is actually going on—the horror of St. Erasmus's martyrdom—is secondary. The realization of what is happening to the central figure can take some moments to be accepted. Is this a good or a bad thing? One could argue that Nicolas Poussin has actually failed in his job: how could an artist make such a tortured and harrowing scene so achingly beautiful? *The Martyrdom of St. Erasmus* is a triumphal lesson of artistically formal content being able to overpower the underlying narrative.

Poussin's linear design combines with the pattern of colors to show a mastery of the technical aspect of painting. He often juxtaposed the primary colors red, yellow, and blue. Here, he contrasts these with their complementary colors: reds/greens and oranges/blues. It is not known whether the artist understood that this would stimulate the visual part of the brain, but it is certain that he knew how the colors would react with each other—the oranges make the blues appear bluer and vice versa. Despite this, the painting was not well received, and Poussin did not receive any further church commissions.

Colors in a painting are like decoys that seduce the eye— like beautiful lines in a poem."

Nicolas Poussin

oil on canvas
126 x 73 in (320 x 186 cm)
Vatican Museums and Galleries,
Vatican City

Argenteuil (1875)
Claude Monet
Musée de l'Orangerie,
Paris, France

Improvisation 19 (1911)
Wassily Kandinsky
Städtische Galerie im
Lenbachhaus, Munich, Germany

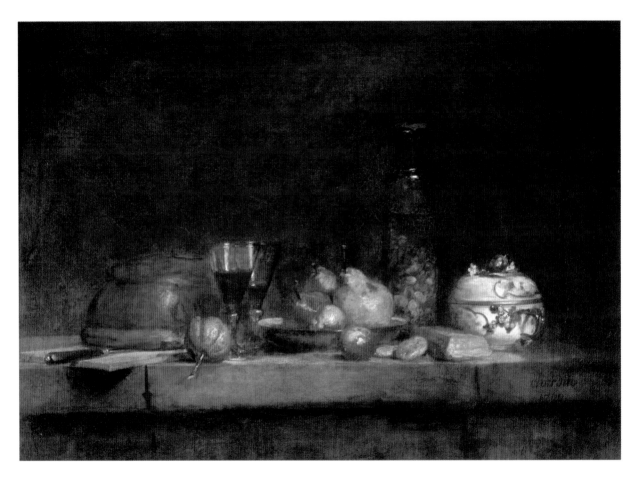

Still Life With Jar of Olives 1760
Jean-Siméon Chardin

Still Life With Jar of Olives was painted during the last nineteen years of Chardin's life and displays his masterly and beautiful intuition for composition. The everyday objects are placed no differently from the way in which a grand historical painting would have been staged. The viewer's eye is drawn into the picture, captured by the glint on the handle of the table knife underneath the upturned bowl. The eyes move naturally to the plate of pears and come to rest on the vertical jar of olives at the Golden Section, placed intentionally at this point to divide the composition so beautifully.

Jean-Siméon Chardin lived during the era when the most fashionable artistic movement in France was rococo; he was a contemporary of François Boucher, who painted fanciful works within the style. In dramatic contrast, Chardin found his subject matter and inspiration from the everyday objects around him. In *Still Life With Jar of Olives*, the use of primary and complementary colors against warm earth and cool gray colors, together with Chardin's skill of built-up paint layers, makes for a quiet and beautiful masterpiece. Later, his work had a profound effect on another great French artist, Paul Cézanne.

> *How many attempts, now happy, now unhappy! . . . He who has not felt the difficulties of his art does nothing that counts."*
> **Jean-Siméon Chardin**

oil on canvas
38 ½ x 28 in (98 x 71 cm)
Musée du Louvre,
Paris, France

Still Life With Lemons, Oranges, and a Rose (1633) **Francisco de Zurbarán** Norton Simon Museum, Pasadena, California, USA

Still Life With a Gilt Cup (1635) **Willem Claest. Heda** Rijksmuseum, Amsterdam, Netherlands

Still Life With Onions (1896–98) **Paul Cézanne** Musée d'Orsay, Paris, France

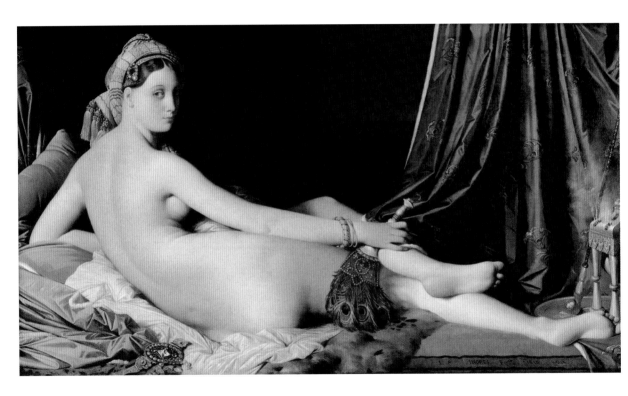

La Grande Odalisque 1814
Jean-Auguste-Dominique Ingres

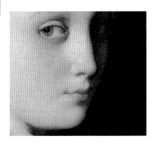

When *La Grande Odalisque* was shown in the Paris Salon, critics noted the literal quality of the odalisque's three extra vertebrae, but failed to recognize the pictorial reasons that led Ingres to make these abstractions. Such decisions were an homage to the idea of beauty inherited, a pictorial equivalent to truth. Ingres understood art as an artifice, not a reality: it is how an artist convinces others that makes his work a work of genius, and here lies the abstract beauty of art. The seemingly paradoxical nature of Ingres is that he combines an extreme sense of realism with this artifice. Ingres was misunderstood in his own time, but his legacy carries on through the works of Henri Matisse and Pablo Picasso.

La Grande Odalisque is one of Jean-Auguste-Dominique Ingres's most beautiful and most famous images, and it has come to symbolize the Western tradition of painting the female nude. It was commissioned by the Queen of Naples, Napoleon Bonaparte's younger sister, just a year before she and her husband were deposed (and he was executed). It was to hang beside another Ingres nude, now lost.

I still admire the same things: in painting, Raphael and his century, the Ancients above all, the divine Greeks; in music, Glück, Mozart, Hayden. My library is composed of scores of books, masterpieces that you know well. With all this, life has many charms."

Jean-Auguste-Dominique Ingres

oil on canvas
35³⁄₄ x 63³⁄₄ in (91 x 162 cm)
Musée du Louvre, Paris, France

Reclining Nude (date unknown)
Jacques-Louis David
Musée des Beaux-Arts et
d'Archeologie, Boulogne, France

Nevermore O Tahiti (1897)
Paul Gauguin
Samuel Courtauld Trust, The
Courtauld Gallery, London, UK

Reclining Nude, Back (1927)
Henri Matisse
Private collection

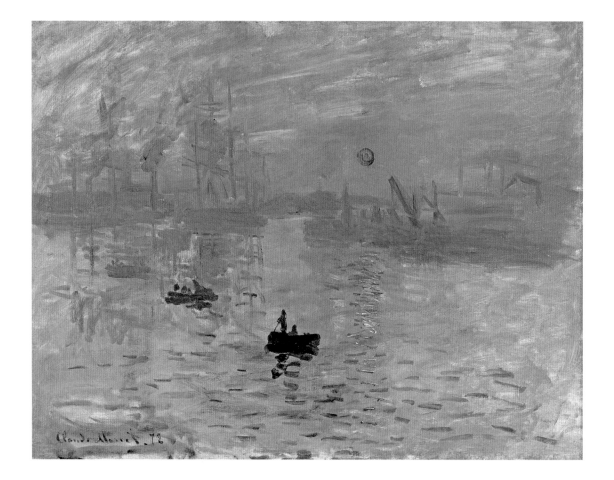

Impression: Sunrise 1872
Claude Monet

In order to create the atmospheric beauty of *Impression: Sunrise*—a perfect visual moment captured as though in the blink of an eye—Monet used short brushstrokes, implying that there was not enough time to paint anything but an immediate and hurried sketch. It was this "sketchiness" that annoyed the critics when the painting was first exhibited. Despite its appearance of a hasty, incomplete image, *Impression: Sunrise* is not a sketch; it is a true finished painting by an artist with an eye for intimate detail.

Impression: Sunrise was the painting that earned the Impressionists their name. When Claude Monet first exhibited it, a derisive critic condemned the whole exhibition as "impressionistic." The short, feathery brushstrokes give the painting a softened, blurred appearance so that viewers look at the scene as if through the veil of an early morning mist rising from the sea. Monet chose mostly blues and violet to compose the scene, with shades of gray and black to make the boats stand out and a vivid orange for the sun and its reflection. By selecting the complementary colors of blue and orange, he ensured that each color stood out more sharply than if he had used them in isolation.

I was supposed to give it a title for the catalog, and since I could not call it just 'View of Le Havre,' I told them: 'Call it Impression'."

Claude Monet

oil on canvas
18⁷/₈ x 24 in (48 x 63 cm)
Musée Marmottan Monet,
Paris, France

The Edge of the Forest at Fontainebleau, Setting Sun
(1850–51) **Theodore Rousseau**
Musée du Louvre, Paris, France

The Burning of the House of Lords and Commons (1835)
J. M. W. Turner
Philadelphia Museum of Art, USA

Nocturne: Blue and Silver (1871)
James McNeill Whistler
Tate Collection,
London, UK

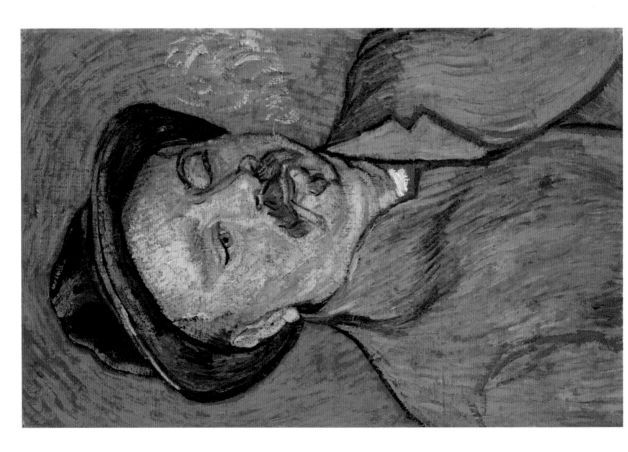

The Man With the Puffy Face
1889 Vincent van Gogh

oil on canvas
14⅛ x 22 in (36 x 56 cm)
Van Gogh Museum,
Amsterdam, Netherlands

Most people, on seeing this man in the street, would be unlikely to think that he was beautiful. His skin sags; he has one eye missing. However, when van Gogh painted this portrait, he made the model an object of beauty. The artist's brush transcends the conventional ideal of beauty and makes the viewer want to keep returning to look at the painting. *The Man With the Puffy Face* was painted a year before van Gogh committed suicide, by which time the artist had soaked up all that he could of the language of art.

Vincent van Gogh had an extraordinary ability to assimilate artistic information and translate it to his own works. Had he painted this model at the start of his career, the painting would not have looked like this. If he had painted it at the same time as *The Potato Eaters* (1885), the man would have retained a deliberate "ugliness," a distortion to shock rather than to inspire viewers. By 1889, van Gogh had moved away from the somberness of the Dutch palette into a softer Provence-inspired palette. Perhaps the beauty of this painting comes not only from the artist's perfect choice of colors, but also because the artist found his subject beautiful.

I want to paint men and women with that something of the eternal, which the halo used to symbolize, and which we seek to convey by the actual radiance and vibration of our color."

Vincent van Gogh

Self-Portrait (1659)
Rembrandt van Rijn
National Gallery of Art,
Washington, D.C., USA

Mona Lisa (1503–06)
Leonardo da Vinci
Musée du Louvre,
Paris, France

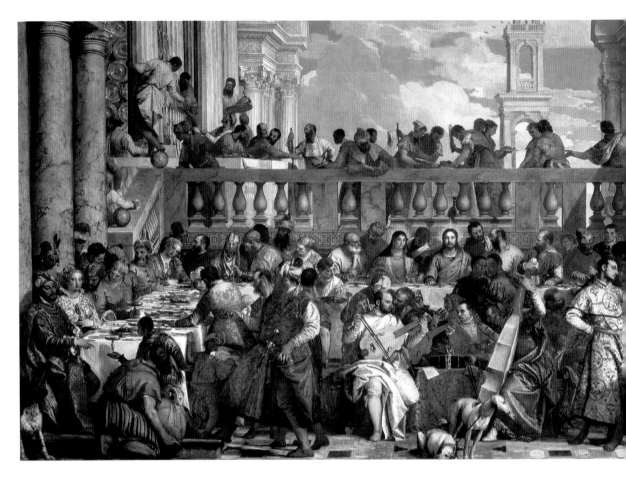

NARRATIVE

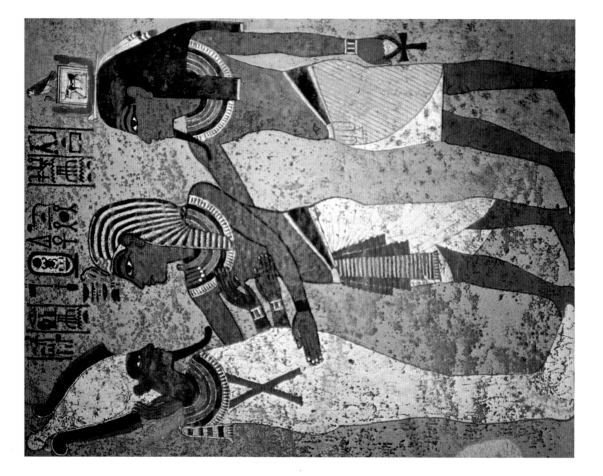

Tutankhamun is Welcomed by Osiris c.1357–49 BCE Artist unknown

Painting was an important part of Egyptian life, and tomb paintings were believed to be essential for passage into the next life. Egyptian tomb paintings were painted with a limited palette, but the colors were symbolically important: black represented death and the afterlife; yellow (or gold) represented the sun and its life-giving power; white was symbolic of purity and power; blue and green symbolized nature: water, sky, vegetation, and new life; whereas red represented the force of life, victory over adversity—and blood.

Each of the walls in the burial chamber of Tutankhamun's tomb was painted with narrative scenes that led from the time of his death to the King's arrival in the afterlife. Egyptian tomb paintings were not painted as truthful depictions of the people portrayed: despite the fact that Tutankhamun, who died very young, must have suffered from poor health, he is depicted as happy, strong, and healthy, as are all those around him. The brown discoloration on the frescoes may well have been caused by the haste of Tutankhamun's burial; it is possible the boy King was interred before the paint had been given enough time to dry.

> ... as my eyes grew accustomed to the light, details of the room within emerged slowly from the mist: strange animals, statues, and gold— everywhere, the glint of gold."
>
> **Howard Carter**
> archeologist

wall painting
Valley of the Kings,
Thebes, Egypt

 Royal Standard of Ur
(c.2600–2400 BCE)
Artist unknown
British Museum, London, UK

 Inspecting the Fields for Nebamun (1350 BCE)
Artist unknown
British Museum, London, UK

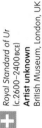

The Elgin Marbles from the Parthenon 447–432 BCE
Artists unknown

The Parthenon was not only intended to be beautiful; its great size and the use of glistening white marble—which would have reflected the sunlight—was a sign to visitors of Athens' great power. The decorative stonework around the temple was highly colored, although today it has lost all its color. The sculptures include a scene from the birth of Athena (left)—to whom the Parthenon was dedicated—who was the goddess of wisdom, military strategy, and victory in war. That the temple is not only a feat of architecture but also one of fine sculpture is due to its overseer, the sculptor Phidias.

The mythological sculptures that decorated the Parthenon were powerful symbols to highlight the supremacy of the city of Athens. The narrative frieze also made the temple a celebration of sculpture, history, literature, philosophy, and fine art. The sculpted images include mythical battles between giants and gods, Greeks and Amazonians, and one between the Lapiths and Centaurs (left). At the feast to celebrate the marriage of Pirithous, the Lapith King, the invited Centaurs got drunk and lecherous and tried to abduct the Lapith women and boys. They were defeated with the help of the god Apollo and Theseus, King of Athens.

[The Parthenon] is dressed in the majesty of centuries. . . . It contains a living and incorruptible breath, a spirit impervious to age."
Plutarch

marble
52 ³/₈ (133 cm) wide
British Museum,
London, UK

Colosseo
(c.70–80)
Artist unknown
Rome, Italy

Terracotta Army (c.210)
Artist unknown
Near Xi'an, Shaanxi
Province, China

Amida Buddha (1053)
Artist unknown
Jocho Byodo-in Temple,
Uji, Japan

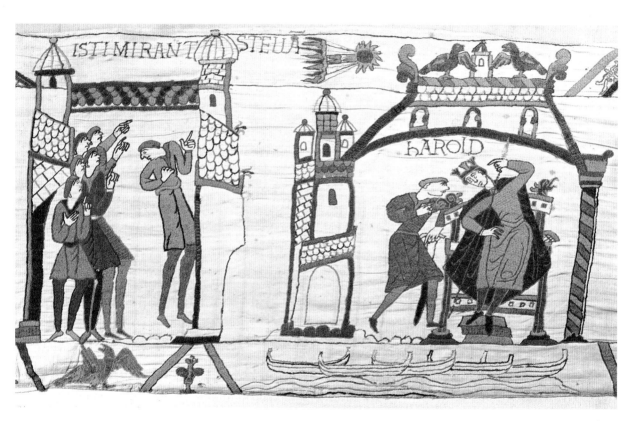

Bayeux Tapestry 1066–77
Artists unknown

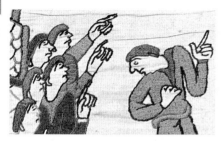

It is unknown who the artists of this work were; many high-ranking women have been attributed to making it, but it is more likely that it was produced by members of a religious order. Although referred to as a "tapestry," the technique employed—stitching instead of weaving—actually makes this an embroidery. Because of the many different hands that produced this work, the embroidery is imbued with an intensity of emotion and experience. Each artisan was intent on portraying his or her own particular historic scene, and each section has become an individual work of art.

The *Bayeux Tapestry* narrates the story of how William I became King of England. It starts with a scene between Edward the Confessor, the King of England, and his cousin Harold, the future King. It leads through Harold's journey to Normandy, where he befriends the Norman King, William. The embroidered story includes the portentous symbol of Halley's Comet, a mysterious sign from the skies signifying impending doom (left). The final scene is of defeated English horsemen fleeing the battlefield after the Battle of Hastings.

The constant sense of movement, with one scene flowing into the next, was what distinguished [the Bayeux Tapestry] from classical narrative friezes or the fixed conventions of medieval picture cycles."

Carola Hicks art historian

woolen yarn on linen
20 x 2760 in (50 x 7000 cm)
Centre Guillaume Le Conquérant,
Bayeux, France

Trajan's Column (113)
Apollodorus of Damascus
Rome, Italy

Mixtec Codex (1200–1521)
Artist unknown
British Museum,
London, UK

The Epic of American Civilization
(1932–34) **José Orozco**
Dartmouth College,
Hanover, USA

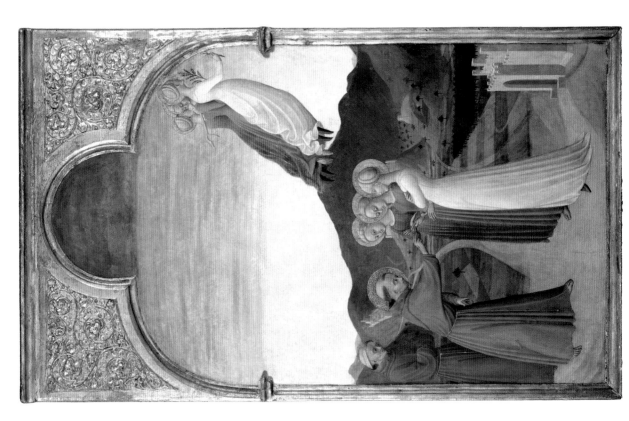

Mystic Marriage of St. Francis
1437–44 Sassetta

tempera on panel
37 x 23 in (95 x 58 cm)
Musée Condé,
Chantilly, France

This is one of eight paintings depicting the life of St. Francis of Assisi from the high altarpiece of the church of San Francesco in Borgo Sansepolcro. The story tells of how, a few months before he died, St. Francis journeyed to Siena with another monk. Both men wear the robes of the religious order known as Franciscan. The saint was seeking aid for his failing sight, and on the journey the two men met three women who announced themselves as Chastity, Poverty, and Obedience, the three virtues St. Francis held most dear. St. Francis, with visible stigmata on his right hand, is blessing Poverty; her dress is the same color as his robe. Like St. Francis, she is "discalced," or barefoot, another symbol of the Franciscan faith.

Tribute Money (1427)
Masaccio
Brancacci Chapel,
Florence, Italy

NARRATIVE
CONTINUOUS NARRATIVE

The continuous narrative is exhibited by two scenes in one: a rhythmic visual movement leads viewers from the three women standing with the monks to the same women flying away. The flying women bear symbols of their identity: Chastity holds flowers, possibly lilies, the symbol of purity. Poverty holds meager twigs, symbolic of a poor, harsh life. Obedience wears a yoke around her shoulders, as animals would when plowing fields. Poverty is the only one looking back at St. Francis.

> *Could it be that at the center of Sassetta's art, there lay no core of sodden sentimentalism but an original and virile mind?"*
>
> **John Pope-Hennessy**
> historian

Primavera (c.1478)
Sandro Botticelli
Galleria degli Uffizi,
Florence, Italy

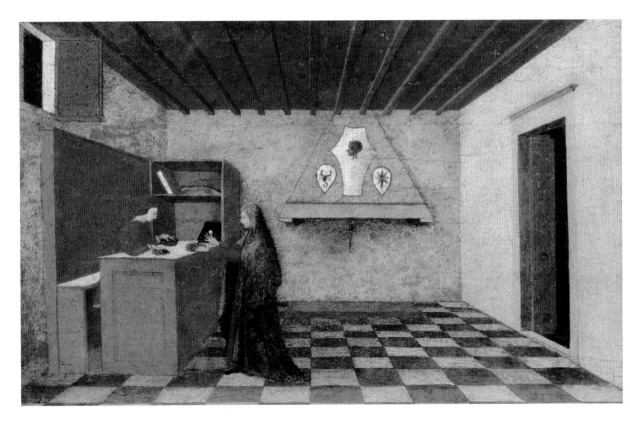

Miracle of the Profaned Host 1465–69
Paolo Uccello

 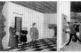 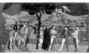 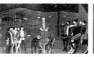 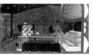

Like a modern-day cartoon, the six panels (above) were intended to instruct without words; in a society that was largely illiterate, paintings were a powerful educational tool. The story hinges on transubstantiation, the belief that the communion bread and wine truly become—and are not simply representational of—the flesh and blood of Christ. When the pawnbroker finds the host, he attempts to cook it, causing rivulets of blood to flow from the profaned host. When Uccello painted the predella, he knew where he wanted his viewers to be placed in order to achieve the perfect view of each panel.

In fifteenth-century Italy, anti-Semitism was rife, and Paolo Uccello's predella tells the story of a Jewish family who "profanes" a Christian host (the "bread" eaten during mass), and are hideously executed for sacrilege. The panels were intended as a deterrent to anyone with thoughts of irreverence. Uccello was a fervent lover of perspective; this can be seen in the way that he created patterns in the floor coverings, internal and external architecture, and the spacing of figures.

[Uccello's wife] used to declare that Paolo stayed at his desk all night, searching for the vanishing points of perspective, and when she called him to bed, he used to say to her: 'Oh what a sweet thing this perspective is!'"

Giorgio Vasari *The Lives of the Artists*

tempera on panel
13 x 23 in (33 x 58.5 cm)
Galleria Nazionale delle Marche,
Palazzo Ducale, Urbino, Italy

The Annunciation (1432–34)
Fra Angelico
Museo Diocesano,
Cortona, Italy

Last Supper Altarpiece (1464–67)
Dieric Bouts
Church of Saint Peter,
Leuven, Belgium

The Story of Papirius (1540–50)
Domenico Beccafumi
National Gallery,
London, UK

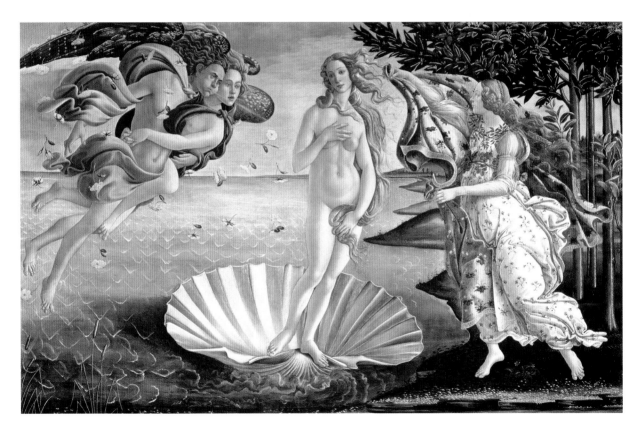

The Birth of Venus c.1486
Sandro Botticelli

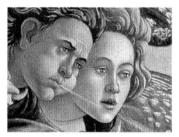

According to an ancient myth, Venus was born from the sea foam, from the sperm that fell into the sea when her father, Uranus, was castrated by his son, Cronos. *The Birth of Venus* depicts the arrival of Venus (or Aphrodite) on the shore in her perfectly sculpted shell, while one of the Three Graces waits with a cape to cover her nudity. The painting is filled with seductively soft arcs: not only the curve of the shell, but also the all-encompassing arc that encloses the goddess, created by the bodies of the other figures. The winds Zephyr and Aura blow to land the shell on which the modest Venus stands, in the traditional "venus pudica" pose, covering her genitalia.

At the time when Sandro Botticelli painted *The Birth of Venus*, Christianity was no longer the only religion; instead, an exciting new belief system was taking hold of the city: humanism. For the first time in centuries, artists did not have to rely solely on the church for patronage. No longer did they have to produce a steady stream of religious scenes, because a new breed of wealthy patrons also wanted their favored artists to produce narrative scenes from literature, history, and ancient mythology. Botticelli depicts the moment Venus, the goddess of beauty, is born to the world, and the viewer is witness to her creation.

Sandro drew far better than was usually the case, so that after his death, artisans used to go to a great deal of trouble to obtain his sketches."

Giorgio Vasari
The Lives of the Artists

tempera on panel
70⁷⁄₈ x 110¹⁄₄ in (180 x 280 cm)
Galleria degli Uffizi,
Florence, Italy

The Triumph of Galatea (1512)
Raphael
Villa Farnesina,
Rome, Italy

Bacchus and Ariadne (1520–23)
Titian
National Gallery,
London, UK

Landscape With the Fall of Icarus
(c.1558) **Pieter Bruegel the Elder**
Musée Royaux des Beaux-Arts,
Brussels, Belgium

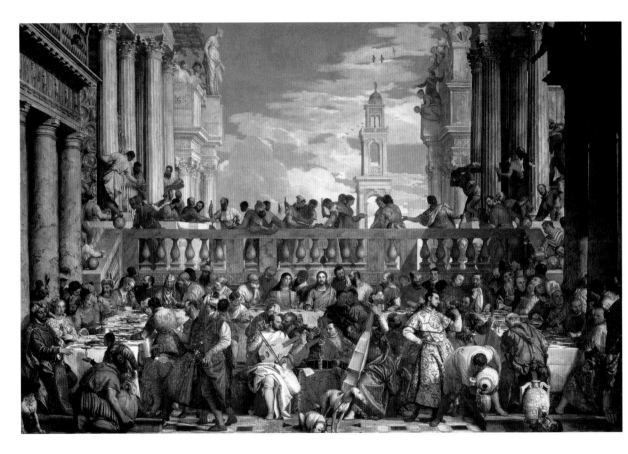

The Wedding Feast at Cana 1562–63
Paolo Veronese

The wedding at Cana is a biblical scene in which Jesus performed his miracle of turning water into wine. In this interpretation, the artist has placed himself, a modern man, in the foreground of the painting almost in the center—he is the musician, dressed in white, his robes disordered to reveal a bright yellow stocking. Opposite him, wearing red, is Titian. Jesus, in the middle of the painting, the sole beatific-looking character, is denoted not only by his halo but also by his expression of serenity. He is one of many important guests—the scene is so crowded that it takes the eye a while to work out where the bride and groom are seated (far left).

This brilliantly colored painting was created shortly after Paolo Veronese arrived in Venice. It is not solely a religious scene; it is a depiction of everyday life. The people are deliberately "staged," reminiscent of a theater. The scene is exquisitely detailed—note the intricately patterned textiles, the birds flying in formation, and the individual place settings. The guests are eating quinces, a fruit said to symbolize marriage.

Veronese was the greatest colorist who ever lived—greater than Titian, Rubens, or Rembrandt because he established the harmony of natural tones in place of the modeling in dark and light that remained the method of academic chiaroscuro."

Théophile Gautier art critic

oil on canvas
267 x 391 in (677 x 994 cm)
Musée du Louvre,
Paris, France

The Burial of the Count of Orgaz
(1586–88) **El Greco**
Church of Santo Tomé,
Toledo, Spain

The Martyrdom of Saint Ursula
(1610) **Caravaggio**
Galleria di Palazzo Zevallos
Stigliano, Naples, Italy

The Night Watch (1642)
Rembrandt van Rijn
Rijksmuseum, Amsterdam,
Netherlands

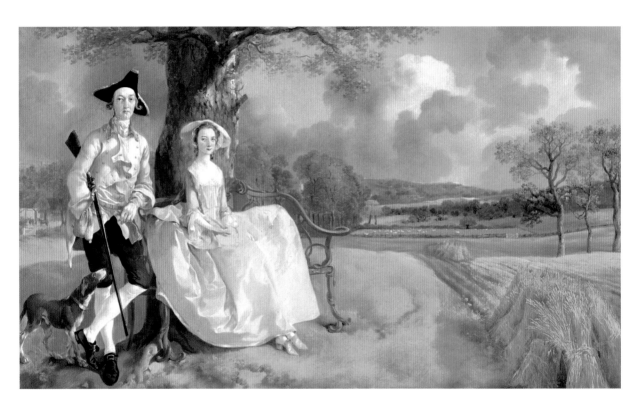

Mr. and Mrs. Andrews c.1750
Thomas Gainsborough

Gainsborough knew the newlywed couple well; they resided in his neighborhood in Suffolk. Robert Andrews was a landowner and farmer, his status in the world acclaimed by the landscape that surrounds him, and his wife, Frances, was the daughter of a cloth merchant, emphasized by the careful arrangement of her skirts. The couple presides over a vast estate, and the land has been tilled in neat rows, indicating a modern and efficient farm. The trees in the background have been parted so that viewers can glimpse the church in which the couple was married. Quintessentially English, the oak tree is closely associated with landed gentry.

In Thomas Gainsborough's first masterpiece, there is a somewhat surreal atmosphere surrounding Mr. and Mrs. Andrews, as though a conversation-piece portrait has unexpectedly found its way into a landscape painting. Indeed, viewers learn more about the sitters' social status from the landscape than they do from the rather stiff portrait. Yet there is something at odds in this marriage portrait: some critics see it as gloriously informal and others as mildly sinister. Is Mr. Andrews's informality a result of feeling at ease with the artist, or does his pose suggest Gainsborough was mildly satirical of the couple's unsuitability to be placed in such a rural landscape?

I must beg pardon for not answering your letter sooner; I have had some plaguesome sitters."

Thomas Gainsborough
Letter to Dr. Rice Charleton

oil on canvas
27¼ x 46⅞ in (70 x 119 cm)
National Gallery,
London, UK

The Arnolfini Marriage (1434)
Jan van Eyck
National Gallery,
London, UK

Madame de Pompadour (1758)
François Boucher
Victoria & Albert Museum,
London, UK

The Brown Boy (1764)
Sir Joshua Reynolds
Bradford Art Galleries and
Museums, Bradford, UK

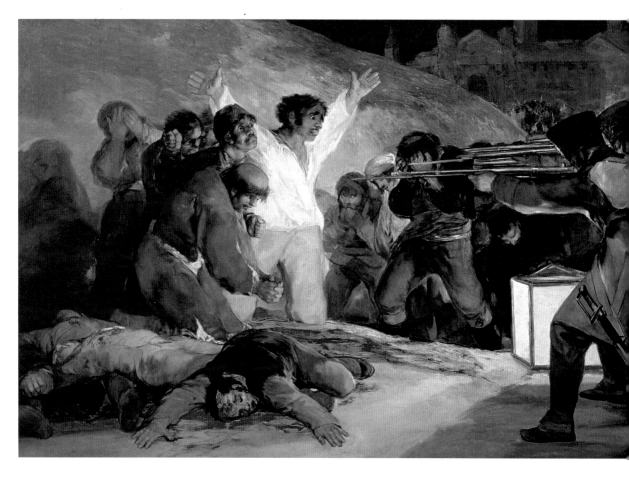

DRAMA

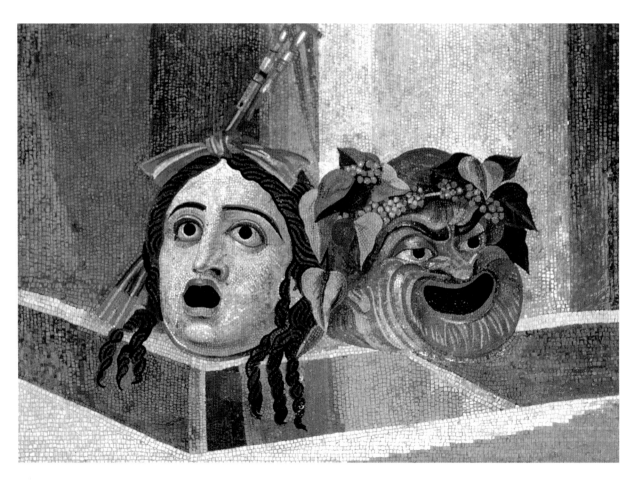

The mosaic is reminiscent of a Georges-Pierre Seurat painting—almost as though the mosaicist has used a pointillist technique. In *La Parade de Cirque* (1889; left) Seurat contrasted warm and cool colors to "trick" the eye—for example dots of orange and blue used in combination to make the eye see brown—and this mosaicist has used small fragments of color in a similar way to create an impression of warmth and coolness. The warmth of the colors used in the comedic mask contrast with the coolness of the colors used for the mask of tragedy. Astonishingly, the mosaic was a utilitarian part of a building, possibly the floor of a swimming pool.

This superb quality mosaic was created by using very small mosaic pieces, culminating in a surprisingly realistic image. The skillful mosaicist was able to emphasize both the objects and their shadows and produce an exquisite observation from real life. The masks have deliberately overdramatic expressions—theatrical masks needed to be exaggerated so everyone in the audience could see them. Here, the masks have been used as props, just as they would have been in the theater, and set up as a still life, as a painter would do today. The modulations of color, tonal shift, and temperature create the realism of the form and an illusion of three dimensions.

> *It follows, therefore, that the agents represented must be either above our own level of goodness, or beneath it, or just such as we are."*
>
> **Aristotle** *Poetics*

mosaic
29 ³⁄₈ in (74.5 cm) high
Musei Capitolini,
Rome, Italy

Emperor Justinian's Court (548)
Artist unknown
Church of San Vitale,
Ravenna, Italy

Lion and Gazelles (c.740)
Artist unknown
Khirbat al-Mafjar,
near Jericho, Palestine

Young Woman Powdering Herself
(1889) **Georges-Pierre Seurat**
Museum of Fine Arts,
Houston, Texas, USA

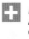

Laocoön and His Sons c.25 BCE

Hagesandros, Athenodoros, Polydorus

This statue depicts the fate of Laocoön, a high priest of Troy, when he was punished by the goddess Athena for mistrusting the Greeks. The horror of the story is re-created superbly by the use of dramatic gestures and expressions, such as the agony on the priest's face. It is the kind of posturing one might have expected to see on the stage. The priest's high status is shown by his large size, in comparison to his two ill-fated sons, whose small stature adds to the tragedy—they have no hope against either the snakes or the all-powerful gods.

Laocoön and His Sons caused great excitement in the art world following its accidental discovery in 1506. Having lain for centuries far underground, the statue was uncovered by mistake during the digging of a well. The discovery of the statue was to have a profound effect on Renaissance sculpture, especially on the works of Michelangelo, who was said to be astonished by the dramatic effect of its realism, seen in the straining veins and muscles, for example. Pliny the Elder described *Laocoön and His Sons* as the greatest work of art in the world.

marble
82⅝ in (210 cm) high
Vatican Museums and
Galleries, Vatican City

Pietà (1499)
Michelangelo
St. Peter's Basilica,
Vatican City

> *Laocoön, follow'd
> by a num'rous crowd,
> Ran from the fort, and
> cried, from far, aloud:
> 'O wretched countrymen!
> what fury reigns?
> What more than
> madness has possess'd
> your brains?"*
> **Virgil** *The Aeneid*

Rape of the Sabines (1581–82)
Giambologna
Loggia della Signoria,
Florence, Italy

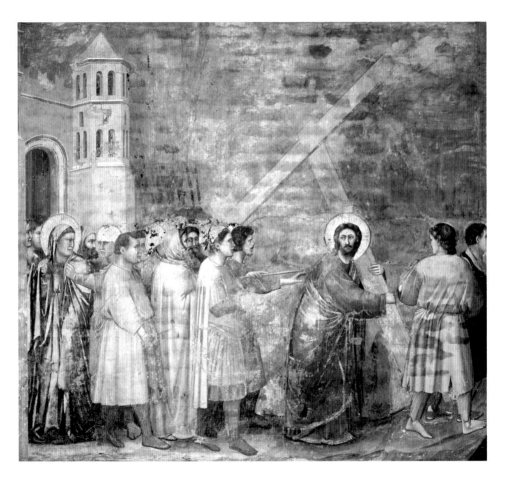

The Road to Calvary c.1304–13
Giotto di Bondone

The panel depicting *The Road to Calvary* is one of a cycle of fresco panels that narrates key events in the lives of the Virgin Mary and Christ; the narrative winds its way around the chapel in three tiers. In this panel the diagonal beam of Christ's cross draws the eye to the top right corner through the next panel to the top center of the wall and back down to the final panel of the lower tier. The diagonal also dominates the composition of other panels and creates a complex dynamic design that is characteristic of Giotto's best work.

In *The Road to Calvary* the Renaissance master Giotto uses a compelling composition to portray a human drama—the agonizing moment that Christ is led away from the Virgin Mary to face his Crucifixion. The scene is intensified by the beam of the cross, which leads the viewer's eye, crucially, down to Mary being pushed away from her son. Giotto heightens the drama by creating tension in the scene through the gulf that divides mother and son; the humanity of the scene is vividly felt through the anguish on Mary's face.

> *So faithful did he remain to Nature . . . one often finds, with the works of Giotto, that people's eyes are deceived and they mistake the picture for the real thing."*

Giovanni Boccaccio poet

fresco
78 x 72 in (200 x 185 cm)
Cappella degli Scrovegni,
Padua, Italy

Bacchus and Ariadne (c.1523)
Titian
National Gallery,
London, UK

Belshazzar's Feast (c.1636)
Rembrandt van Rijn
National Gallery,
London, UK

Liberty Leading the People (1830)
Eugène Delacroix
Musée du Louvre,
Paris, France

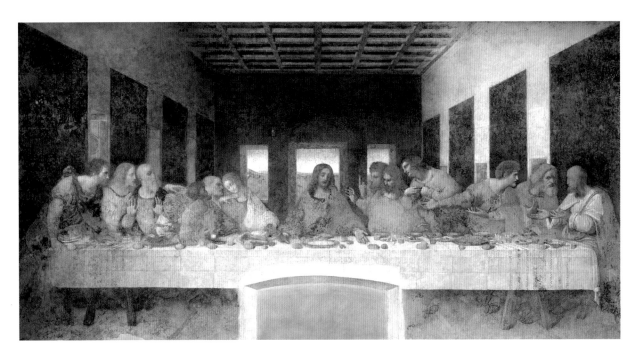

The Last Supper 1495–98
Leonardo da Vinci

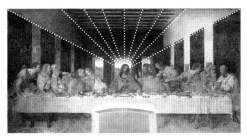

The Last Supper captures the moment when Christ announces that he has discovered a betrayer among the Apostles, and the drama is intensified by the gestures of the figures—outstretched arms, tilted heads, pointing fingers. If extended downward, the lines of the ceiling beams lead to Jesus; the linear perspective converges to the vanishing point at his head, highlighted by the window behind him. The triangular figure of Christ is echoed in the triangle of space next to him and in the larger triangle that encompasses all the figures.

In The Last Supper, the scene is filled with dramatic tension and arresting movement: Christ is not only the central figure of the painting, but also of the drama itself. The work is not a true fresco: these are created by painting water-based pigments into wet plaster. Here, Leonardo da Vinci used the "secco" technique, painting with oil paints on a dry wall. The haziness is caused by the deterioration of the paint.

Leonardo was so pleased whenever he saw a strange head or beard or hair of unusual appearance that he would follow such a person a whole day, and so learn him by heart, that when he reached home he could draw him as if he were present."

Giorgio Vasari The Lives of the Artists

tempera on gesso, pitch, and mastic
181 x 346 in (460 x 880 cm)
Santa Maria delle Grazie,
Milan, Italy

The Creation of Adam (1508–12)
Michelangelo
Sistine Chapel Ceiling,
Apostolic Palace, Vatican City

The Conversion of St. Paul
(1600–01) **Caravaggio**
Cappella Cerasi, Santa Maria
del Popolo, Rome, Italy

The Crossing of the Red
Sea (c.1634) **Nicolas Poussin**
National Gallery of Victoria,
Melbourne, Australia

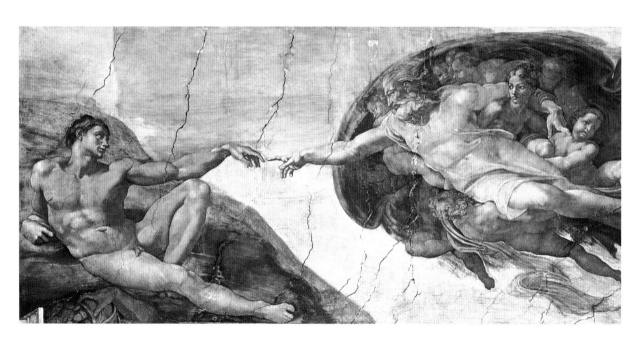

The Creation of Adam 1508–12
Michelangelo

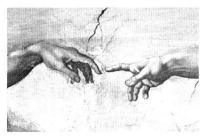

Adam's languid pose—the painful fluidity of his limbs and searching facial expression—creates emotional tension. Is God actually creating Adam here? He is not quite real yet is on the cusp of becoming so. Already incarnate, as he reaches out to God, Adam seems to be receiving a divine—and vital—channel of strength. The space between the outstretched fingers almost crackles with intensity. Using every line and plane to ensure that the eye looks toward the the center of the scene, Michelangelo imbues that "blank" space with an almost searing dramatic tension, as the viewer wills the two fingers to touch.

The Creation of Adam depicts a key moment in the creation story, and it is the most dramatic scene in the cycle of frescoes that Michelangelo painted on the ceiling of the Sistine Chapel. The ceiling was covered in sections (*giornata*) with plaster, which the artist painted onto before the plaster could dry. This process and the precise brushstrokes give the figures a freshness and luminosity. The clarity of the design makes this scene stand out amid all the others.

My stomach's squashed under my chin, my beard's pointing at heaven, my brain's crushed in a casket, my breast twists like a harpy's. My brush, above me all the time, dribbles paint so my face makes a fine floor for droppings!"
Michelangelo

fresco
189 x 90³/₈ in (480 x 230 cm)
Apostolic Palace, Vatican City

The Carrying of the Cross (1335)
Simone Martini
Musée du Louvre,
Paris, France

The Death of Socrates (1787)
Jacques-Louis David
Metropolitan Museum of Art,
New York, USA

The Third of May, 1808 (1814)
Francisco de Goya
Museo del Prado,
Madrid, Spain

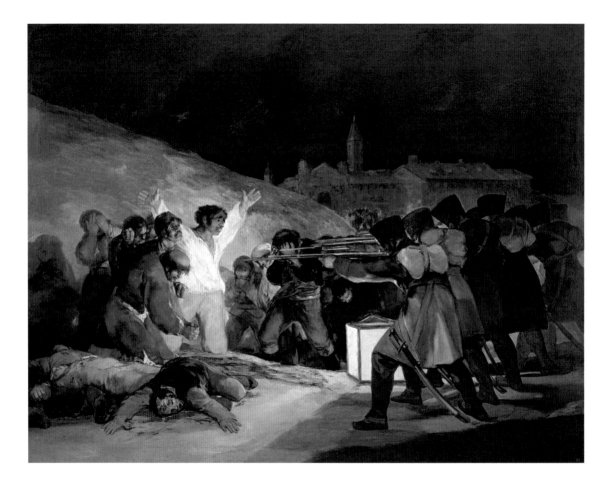

The Third of May, 1808 1814
Francisco de Goya

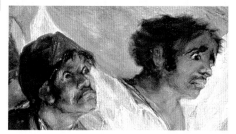

The Third of May, 1808 depicts the Spaniards as martyred heroes, with the tragic, Christ-like figure lit brilliantly—his white shirt gleaming, soon to be covered with blood. The French soldiers have no identity—their heads are lowered, and the artist suggests that the guns they hold have replaced their faces—and the brutal weapons of death have become an integral part of their bodies. The bloody corpses, sorrowing priests, palpable fear on the faces of those being led to die, and heroic attitude of the central figure lead the viewer to gasp with horror.

Francisco de Goya lived in a Spain blighted by war and oppression. This painting was one of several works he made to show his patriotism, and it triumphantly expresses the drama of a particularly tragic event. In 1808, Napoleon Bonaparte's soldiers invaded, and any Spaniards who protested were executed. Napoleon ousted King Charles IV, and Joseph Bonaparte became Spain's new ruler. After the fall of Napoleon in 1814, Charles IV's son became King and ushered in a new age of terror. Goya was scarred forever by the brutalities. He produced a number of similarly themed paintings, and in later life his once optimistic painting style became darker and more disturbed.

I cannot forgive you for admiring Goya. . . . I find nothing in the least pleasing about his paintings or his etchings. . ."

Prosper Merimee dramatist

oil on canvas
105 x 136 in (268 x 347 cm)
Museo del Prado,
Madrid, Spain

The Death of Socrates (1787)
Jacques-Louis David
Metropolitan Museum of Art,
New York, USA

Guernica (1937)
Pablo Picasso
Museo Reina Sofía,
Madrid, Spain

Execution (1995)
Yue Minjun
Private collection

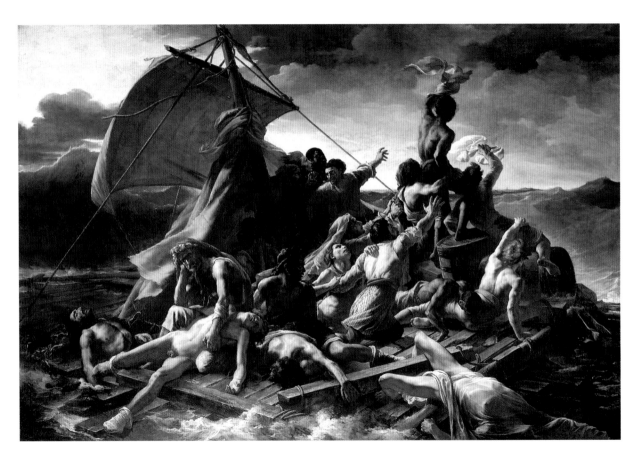

The Raft of the Medusa 1819
Théodore Géricault

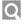

This epic depiction of a true story has become an iconic image of the Romantic Age, and it was made by Théodore Géricault in protest against the government. He questioned survivors about their ordeal and set about making his painted narrative one that would evoke strong emotions, painting from live models, wax figurines, and corpses. His use of such a large canvas draws in the viewer to the center of the action, and the use of chiaroscuro highlights some figures—a suggestion of hope, the possibility that they might live—but blights others, whom viewers feel are destined to perish.

The Raft of the Medusa depicts a very dramatic moment from a real-life event that took place in 1816. A French Royal Navy frigate on a routine journey to Senegal ran aground on a sandbank. On discovering there were not enough lifeboats, 150 sailors were left to save themselves; they made an enormous raft from the ship's timbers, on which they floated for more than two weeks. There were few survivors. Most of the action in the painting points forward, toward the sun—but in the lower right-hand corner lies a corpse, already doomed as it starts to disappear off the raft. The intense expressions and frantic gesturing of the sailors add dramatic tension to the tragic scene.

Monsieur Géricault seems mistaken. The goal of painting is to speak to the soul and the eyes, not to repel."

Marie-Philippe Coupin de la Couperie artist

oil on canvas
193¼ x 281⅞ in (491 x 716 cm)
Musée du Louvre,
Paris, France

The Third of May, 1808 (1814)
Francisco de Goya
Museo del Prado,
Madrid, Spain

Liberty Leading the People (1830)
Eugène Delacroix
Musée du Louvre,
Paris, France

Washington Crossing the Delaware
(1851) **Emmanuel Gottlieb Leutze**
Metropolitan Museum of Art,
New York, USA

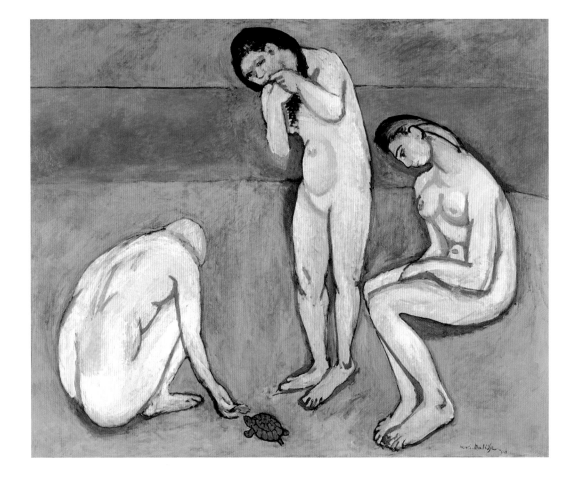

Bathers With a Turtle 1908
Henri Matisse

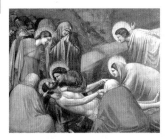

In 1907, Matisse visited Italy, where he discovered early "primitives" and works by early Renaissance masters, including Giotto, over which he enthused. The three figures in Matisse's *Bathers With a Turtle* evoke the sentiment and composition of Giotto's *Lamentation of the Death of Christ* (left). Matisse was so impressed by the memory of this painting that he was able to return home and imbue his work with a similar pathos. He wrote, "When I see the Giotto frescoes at Padua I do not trouble myself to recognize which scene of the life of Christ I have before me, but I immediately understand the feeling from it, for it is in the lines, the composition, the color."

The dramatic focus of all three figures in this painting is directed toward the turtle, a humble metaphor for humanity. The crouching back of the figure on the left echoes Giotto's shrouded, seated figures, hunched in their misery in *Lamentation of the Death of Christ* (c.1304–13; above). It also replicates the curved, protective shell of the turtle. Henri Matisse's central figure references Giotto's grieving Mary, and the seated woman emulates the sorrowful woman clasping the corpse's feet. Matisse returned to this theme in his collage *Sorrows of the King* (1952), depicting the drama of the "reflection and contemplation of life and death."

For me Giotto is the summit of my desires, but the road leading to an equivalent, in our age, is too long for one lifetime. Meanwhile, it leads through interesting stages."
Henri Matisse

oil on canvas
70 ½ x 87 ¾ in (179 x 223 cm)
Saint Louis Art Museum,
Missouri, USA

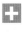

Christ Crowned With Thorns
(1490–1500)
Hieronymus Bosch
National Gallery, London, UK

The Vagrants (1868)
Frederick Walker
Tate Collection,
London, UK

Guernica (1937)
Pablo Picasso
Museo Reina Sofía,
Madrid, Spain

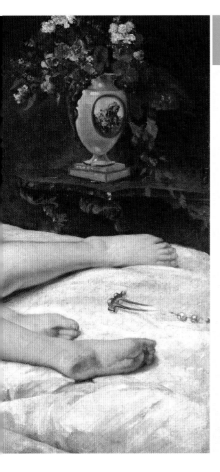

EROTIC

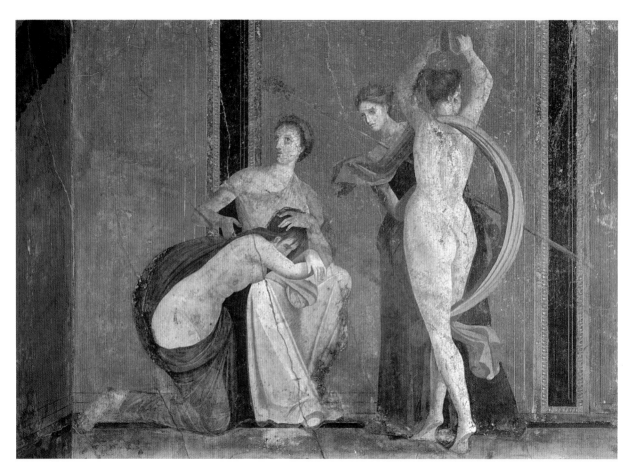

Villa dei Misteri—Scourged Woman and Dancer With Cymbals
70–60 BCE Campanian artist

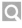

The fresco cycle was constructed to emulate a sculptural frieze, and this scene is the climax of the ritual. Twenty-nine figures, set against a vermilion red background with a green floor, occupy a real—albeit shallow—space. To the left—out of the picture and arising from a corner—is a black-winged figure who whips the kneeling victim. The whipping was intended to purify her before a mystic marriage to Dionysus. The exhaustion of the woman is evident; her hair wet with sweat emphasizes how distraught she is. As an onlooker watches, the nude dancer clashes her cymbals in culmination of the erotic tension.

This detail is part of a series of frescos decorating the Villa dei Misteri near Pompeii, and it depicts an ancient ritual that dates back to 1000 BCE. It is not known if such rituals took place in the salon, the room in which these paintings were created, but the bedrooms were close by, and this sado-masochistic erotic scene may have been painted as titillating pornography. The ritual was performed in worship of the Greek god Dionysus, the god of fertility in nature, also known as Bacchus, the god of wine. No one knows if the fresco was a direct copy from a Greek original, but what is clear is that it is a painted masterpiece full of natural observation and realism.

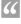

Pentheus: 'Of what fashion be these mysteries?'
Dionysus: 'Tis secret, save to the initiate.'
Euripides *The Bacchae*

wall fresco (detail)
63 ¾ in (162 cm) high
Pompeii, Italy

Etruscan Erotic Scene (c.550 BCE)
Artist unknown
Tomb of the Bulls, Monterozzi
Necropolis, Tarquinia, Italy

Suburban Baths (c.100 BCE)
Artist unknown
Pompeii, Italy

Kandariya Mahadeva Temple
(c.1000) **Artist unknown**
Khajuraho, Madhya
Pradesh, India

Sculptural Figures on Kandariya Mahadeva Temple, Khajuraho c.1000 Hindu artists

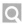

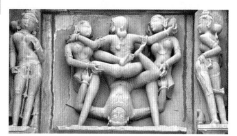

Central to the religion of Hinduism is the sanctity of the sexual act of love making and that it should be a pleasurable and divine experience. The mithuna (figures performing sexual acts) adorn the outer temples at Khajuraho and are spiritually symbolic of fertility and happiness. It is also believed that the mithuna surround the temple with love and protect it from evil spirits. Some of the erotic sculptures at Kandariya Mahadeva Temple are thought to exhibit Tantric poses. Tantricism is a belief in cosmic sex as a philosophy and a spiritual yoga.

Kandariya Mahadeva Temple is the largest and most impressive of twenty-five temples at Khajuraho, India, which is now a world heritage site. The temples were built by order of the Chandela kings in c.1000, and Kandariya Mahadeva was begun by King Vidyadhara. The temples are famous for their richly decorated sculpture carved from fine sandstone—a material that allowed the sculptors to be able to carve with ease and produce beautiful and sophisticated works. There are more than 900 sculptures adorning the temple at Khajuraho, and many of these are erotic figures. They are carved with fine detail and a boldness of erotic expression.

In the beginning this world was the Self alone in the form of a Person. Looking around he saw nothing else than himself. . . . "

Brihadaranyaka Upanishad

sandstone
98 ft (30 m) high
Khajuraho,
Madhya Pradesh, India

Sunga Empire Sculpture (India)
(1st century BCE) **Artist unknown**
Metropolitan Museum of Art,
New York, USA

Villa dei Misteri (c.70–60BCE)
Campanian artist
Pompeii, Italy

Leda and the Swan (c.300)
Artist unknown
Cyprus Museum,
Nicosia, Cyprus

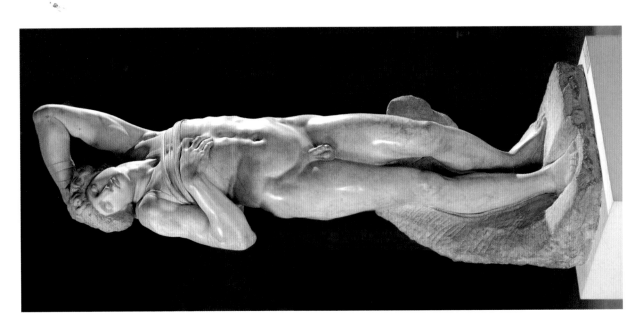

The Dying Slave 1513–16
Michelangelo

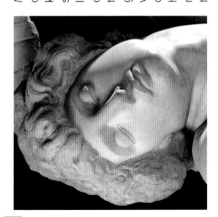

Michelangelo's statues are charged with a disturbingly erotic quality. In his best known work, *David*, the figure is free standing and the marble is smooth with lifelike luster, yet with this statue the form appears to emerge from the lower half of the rough stone itself. It exhibits the fury gnawing away at the soul of the captive, whose expression belies an erotic contentment with the situation in which he finds himself. The forms of the bulging muscles and the straining tendons seem to bring the marble alive.

The Dying Slave is an idealized, homoerotic visualization of a beautiful but doomed young man. In 1505 its sculptor, Michelangelo, was commissioned to create a series of slave statues to adorn the tomb of Pope Julius II. After the Pope's death, and the accession of a new Pope, the design was deemed too elaborate. Michelangelo continued to sculpt the slaves in different poses, and it is known that these figures are slaves, not free men, by the agony of their limbs and the sensation that they are striving not only physically but also mentally. Michelangelo drew his inspiration from the sculpture of the classical worlds of ancient Greece and Rome, of handsome young men typifying the cult of youth.

> *If there is some good in me, it is because … along with the milk of my nurse I received the knack of handling chisel and hammer."*
> **Michelangelo**

marble
82¼ in (209 cm) high
Musée du Louvre,
Paris, France

The Ecstasy of St. Theresa
(1645–52) **Gianlorenzo Bernini**
Santa Maria della Vittoria,
Rome, Italy

Jacob and the Angel
(1940–41)
Jacob Epstein
Tate Liverpool, UK

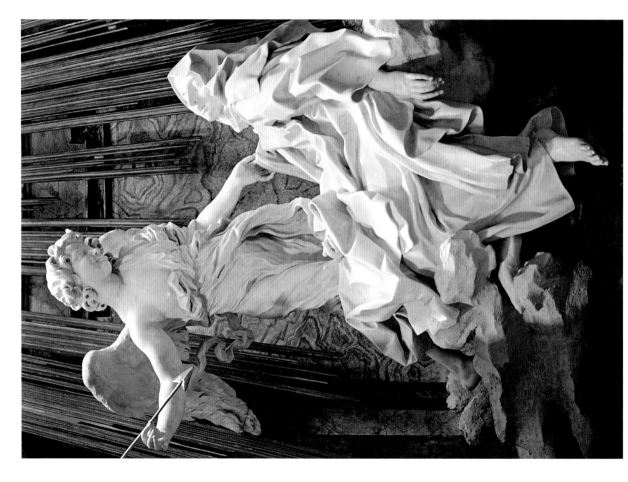

The Ecstasy of St. Teresa 1645–52
Gianlorenzo Bernini

The word "ecstasy" refers both to an intense religious experience and an intense sexual experience. Gianlorenzo Bernini's sculpture of St. Teresa takes the saint's autobiography as its starting point. Teresa believed that Jesus Christ appeared regularly to her, but in body, not in spirit. She wrote about her physical experiences of Christ in language that was intensely erotic in nature. In *The Ecstasy of St. Teresa*, produced for the church of Santa Maria della Vittoria in Rome, the artist depicts the saint seemingly at the moment of both death and orgasm.

The look on the saint's face is indicative of both her last breath and a gasping orgasm. The facial expression refers to the metaphysical idea that an orgasm equates to a "little death." Unusually, the angel next to St. Teresa is equally sexualized; she is identifiably female, her draperies clinging to her curvaceous body. Bernini's sculpture is filled with movement: golden rods seem to be leading Teresa's way to heaven, and the arching attitude of her body shows that she is both giving up her soul and is sublimely happy about meeting Jesus.

> *I saw in his hand a long spear of gold … he appeared to be thrusting it at times into my heart, and to pierce my very entrails; when he drew it out, he seemed … to leave me all on fire with a great love of God."*
> **St. Teresa of Avila**

marble
137¾ in (350 cm) high
Santa Maria della Vittoria,
Rome, Italy

Mary Magdalen in Ecstasy (1606)
Caravaggio
Private collection

Danaë (1917)
Gustav Klimt
Galerie Würthle,
Vienna, Austria

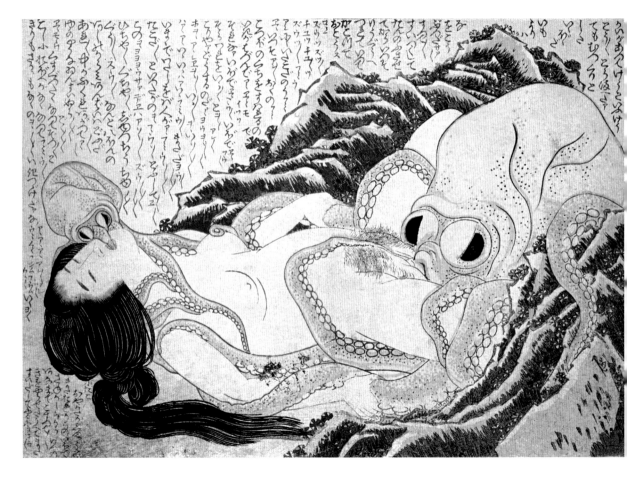

The Dream of the Fisherman's Wife 1814
Hokusai Katsushika

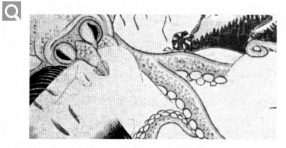

In *The Dream of the Fisherman's Wife*, Hokusai depicts a diving woman having sex with two octopi. Her face shows ecstatic pleasure, and the peaks of the waves indicate the woman's orgasm. There is, however, a sinister side to the image, as the woman must risk her life in the pursuit of sexual pleasure. The long pink tentacles may be seeking out her erogenous zones, but they are also binding her. Most sinister of all is the engulfing kiss of the smaller octopus, suffocating her at the moment of orgasm.

There is no pretence that *The Dream of the Fisherman's Wife* is anything except an erotic work, and this woodblock formed part of three volumes of erotic art (or Shunga). That Hokusai is famous in the West for his landscapes, such as *Thirty-Six Views of Mount Fuji* (1826–33), can be attributed to the Western world's repressed attitude toward erotica. The existence of Shunga was known by very few in the nineteenth century, and the forbidden subject of oral sex and the depiction of pubic hair (seldom seen in Western art of this time) would have been considered obscene.

> *Ever since I was six years old I have drawn things I saw about me. . . . It was only when I was seventy-three that I understood a little of the anatomy of animals and the life of plants."*
>
> **Hokusai Katsushika**

woodcut
British Library,
London, UK

The Kiss (1803)
Kitagawa Utamaro

Odalisque and Slave (1842)
Jean-Auguste-Dominique Ingres
Walters Art Gallery, Baltimore,
Maryland, USA

Maid With a Sake Flask (c.1850)
Utagawa Hiroshige

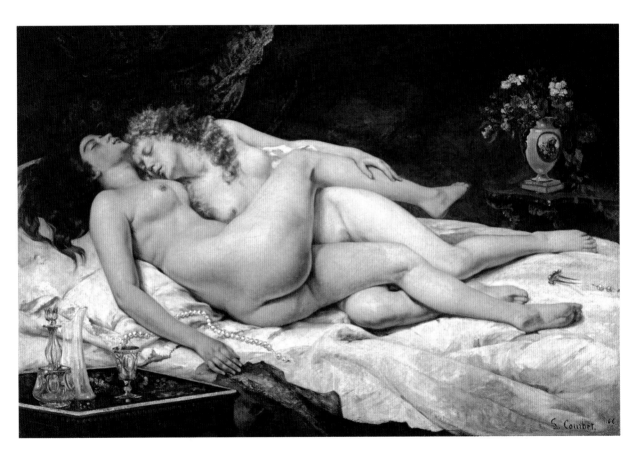

The Sleepers 1866
Gustave Courbet

The Sleepers was inspired by the new art of pornographic photography and shows the lovers entwined in a passionate embrace. With its softer brushstrokes, the painting has romantic overtones and also shows the influence of rococo art, such as the erotic works by Jean-Honoré Fragonard. *The Sleepers* earned notoriety for both Courbet and Kahlil-Bey. Within a few of years of commissioning it, the diplomat was ruined by his gambling addiction and his collection sold. When *The Sleepers* was exhibited in Paris in 1872, the buyer was investigated by the police.

Diplomat and inveterate gambler Khalil-Bey commissioned Gustave Courbet to create *The Sleepers* and *Origin of the World* (1866). Both paintings are a voyeur's dream. In *The Sleepers*, lesbian lovers, tired out from love making, are being observed by the voyeuristic viewer. The voyeuristic aspect of this painting is increased by the painting's large size, almost as though viewers are standing on the edge of the room peering in. The painting's subject echoes popular culture of the time: a fascination with lesbianism—but from the point of view of men being titillated by it.

In our so very civilized society it is necessary for me to live the life of a savage. I must be free, even of governments. The people have my sympathies, I must address myself to them directly."

Gustave Courbet

oil on canvas
53 1/8 x 78 3/4 in (135 x 200 cm)
Musée du Petit Palais,
Paris, France

The Chemise Removed or
The Lady Undressing (c.1778)
Jean-Honoré Fragonard
Musée du Louvre, Paris, France

The Kiss (1907–08)
Gustav Klimt
Osterreichische Galerie
Belvedere, Vienna, Austria

The Embrace (1917)
Egon Schiele
Osterreichische Galerie
Belvedere, Vienna, Austria

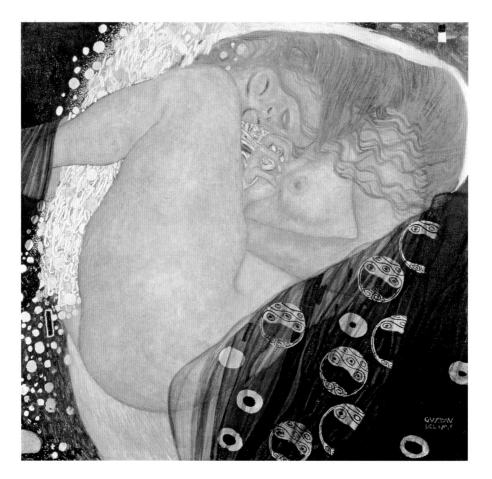

Danaë 1907
Gustav Klimt

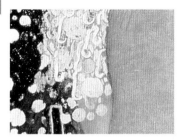

The sensuality of the Byzantine-style gold—a trademark of Klimt's later style and indicative of his life in opulent prewar Vienna—and the sweep of the gauzy, gold-patterned material frame the naked woman and caress her body. Behind her powerful, curvaceous leg lies the focal point of the painting: the unseen vagina. Klimt makes use of dramatic action in combination with smooth directional lines—the shower of gold, the tilt of the woman's head, and the incline of the forearm, with its hand obscured by an ecstactically pressed thigh—to draw the viewer's eye toward the center of the canvas.

Gustav Klimt famously commented: "All art is erotic." He was inspired by the sight of the female orgasm, and his work includes scores of studies of women masturbating. In this painting, Klimt has depicted Danaë, daughter of Acrisius, at the moment of orgasm. The shower of gold that cascades from above is the god Zeus, entering her body. The god has discovered that King Acrisius has locked away his daughter, in an attempt to thwart a prophecy that his daughter's child will murder him. Zeus impregnates Danaë, and their son, Perseus, later kills his grandfather.

*I want to liberate myself.
I want to break away from all these unpleasant, ridiculous aspects which restrict my work.
I refuse all official support,
I will do without everything."*

Gustav Klimt

oil on canvas
30 ³/₈ x 32 ⁵/₈ in (77 x 83 cm)
Galerie Würthle, Vienna, Austria

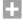

The Turkish Bath (1862)
Jean-Auguste-Dominique Ingres
Musée du Louvre,
Paris, France

Sleep (1866)
Gustave Courbet
Musée des Beaux-Arts,
Paris, France

Sleeping Nude (1950)
Lucian Freud
British Council Collection,
London, UK

Reclining Woman With Green Stockings 1917
Egon Schiele

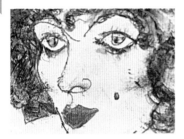

The world inhabited by this model in her green stockings is not the glittering, decadent, sexually confident Vienna usually depicted in works of this era; Schiele's world is grubby, base, and seedy. The figure he paints is interesting, rather than beautiful; she is in short-lived lust rather than in love. Schiele's erotic art is not as sensuous as that produced by his mentor, Gustav Klimt, nor is it as erotic. As with all Schiele's work, his erotic figures are twisted, distorted, seemingly less at ease in their sexual roles than Klimt's happily masturbating women. His pictures convey the idea of sexual experimentation, often tinged with disappointment or regret.

Painted a year before the artist's death, aged twenty-eight, *Reclining Woman With Green Stockings* has become one of Egon Schiele's most famous erotic works (of which there are many). The bold lines, twisted figure, and abstract splashes of color, almost but not quite filling the intended shape, seen in this painting are recognized characteristics of his erotic paintings. Schiele is often allied with the Austrian Secessionists and the German Expressionists, but his work is not easily defined by any single artistic movement. He was a unique talent who infused his ideas with aspects of contemporary art movements and created a truly unusual style, decades ahead of its time.

> *I do not deny that I have made drawings and watercolors of an erotic nature. But they are always works of art."*
>
> **Egon Schiele**

gouache and black crayon
on paper
11 ⁵/₈ x 18 ¹/₈ in (29 x 46 cm)
Private collection

Naked Maya (1800)
Francisco de Goya
Museo del Prado,
Madrid, Spain

Nymphs and Satyr (1873)
William-Adolphe Bouguereau
Sterling and Francine Clark Art
Institute, Massachusetts, USA

Water Serpents (1904–07)
Gustav Klimt
Osterreichische Galerie
Belvedere, Vienna, Austria

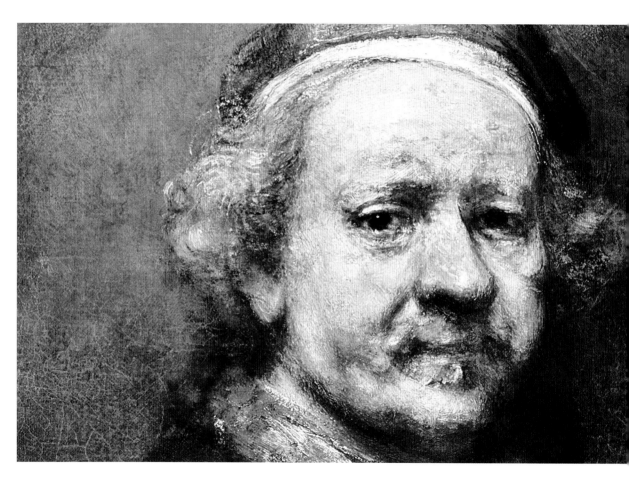

REALISM

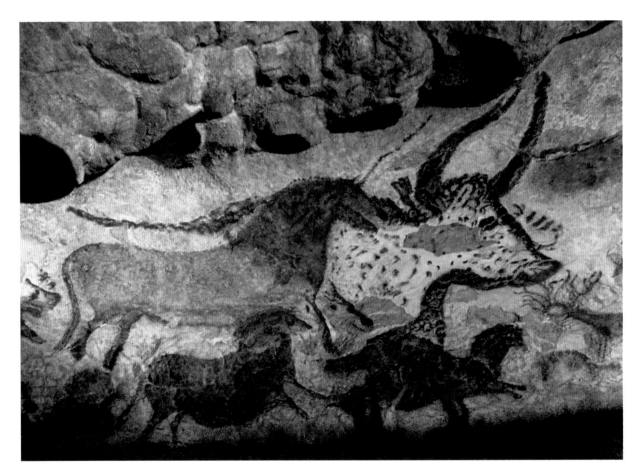

Cave Painting, Bull and Horses c.14,000 BCE
Lascaux artists

The artists who made these images probably did so for magic and ritual rather than for art. The animals depicted—predominantly horses, deer, bulls, and bison—were crucial for survival, and hunters may have believed that these drawings gave them control over the animal spirits and that a hunt would be successful. The small red ocher marks above the bull's head are thought to represent "abstract concepts" for traps to assist with magic. The deer to the right were drawn at a different time from the bull and horses—it is possible that the paintings were made several thousand years apart.

Some of the most wonderful and sublime examples of humans' earliest drawings can be found in the caves of Lascaux in the Dordogne, France. They are a magnificent example of how humankind does not get any better in terms of art, but merely develops. Exquisitely drawn and observed, they were made with materials that artists still use today—the most basic of means: charcoal made from burned wood and red ocher from the earth. It is clear that some of the rock formation suggested forms to the artists.

The trouble is, we've been taught what to see and how to render what we see. If only we could be in the position of those men who did those wonderful drawings in Lascaux and Altamira!"

Pablo Picasso

pigment on rock
Lascaux, Dordogne, France

Ubirr Rock Painting (c.40,000 BCE)
Artists unknown
Ubirr, Kakadu National Park, Australia

Altamira Cave Paintings (c.15,000 BCE) **Artists unknown**
Santillana del Mar, Cantabria, Spain

Toreador Fresco (c.1550–1450 BCE)
Artists unknown
Heraklion Archaeological Museum, Crete, Greece

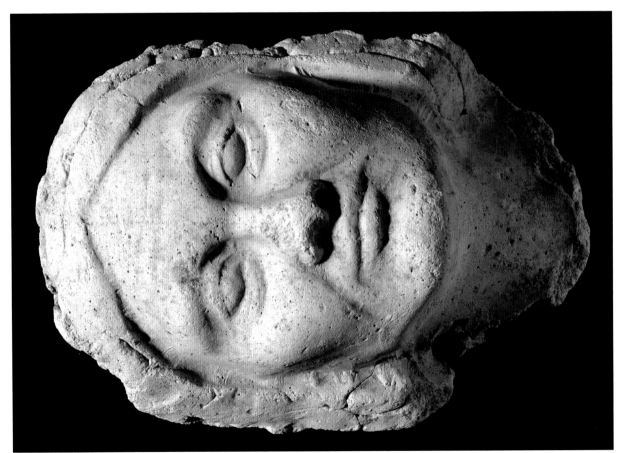

Plaster Head of an Old Woman
c.1370–50 BCE Workshop of Thutmose

In this portrait head, viewers can observe wrinkles around the eyes, lips that are re-created very tenderly, and a nose that is shaped as a real nose, not idealized. At the time that the plaster head was created, people were considered old when they reached their mid-thirties. For this reason, scholars assume that this woman was a venerated "wise woman," whose age was considered a blessing, not a curse. Or perhaps the portrait head was sculpted for a tomb, showing the occupant as a model of wisdom during the afterlife.

In 1912, a team of German archeologists working at the site of the ancient Egyptian city of Tel el Amarna discovered the workshop of a sculptor, Thutmose. The sculptures they found made them believe he was the chief sculptor of Pharaoh Akenaten. Among the sculptures were the now-famous polychromed bust of Nefertiti and twenty-two plaster portrait heads (of eight royal figures). This plaster head of an old woman is one of those twenty-two uncovered in his workshop. It is extraordinary for two major reasons. Firstly, it is extremely rare to see depictions of such old age; the norm for portraits of this time was a depiction of a perfect young model. Secondly, it is remarkable for its sheer brilliance of realism.

In the elder days of art, workers wrought with greatest care each minute and unseen part, for the gods see everywhere."

Henry Wadsworth Longfellow

gypsum
Ägyptisches Museum und Papyrussammlung, Berlin, Germany

Terracotta Army (c.210 BCE)
Artist unknown
Near Xi'an, Shaanxi Province, China

Romano-Egyptian
Stucco Head of a Boy (200)
Artist unknown
Private collection

The Warrior's Leave-taking c.500 BCE

Euthymides

This red figure vase, signed by the painter Euthymides, exhibits a groundbreaking type of observed realism. This is particularly evident in the foreshortened foot, which is depicted as viewed from the front, not from the side, as of old. Other forms still mostly display the language of the artist's predecessors, but the configuration of the foot is gloriously convincing. It has to be noted that the drawing of an Egyptian foot shows, most commonly, the big toe on the outside, therefore no other toes can be seen; here, Euthymides has masterly drawn all the toes with great clarity and delight.

For more than 2,000 years the Egyptian concept of painting the figure in components of recognizable parts prevailed: the profile of a head with the frontal view of an eye, or the front of a chest with the profile of legs. This was not because artists were ignorant of the human form; on the contrary, this type of figuration was a recognizable symbol for the figure. However, in c.500 BCE, in Greece, the concept for depicting figures and objects changed. No great Greek painting survives from this period, but the new realism can be seen on many decorated vases.

While Red Figure is in principle just as linear a technique as Black Figure, its lines can be softened and modulated ... stressing some contours and depreciating others increases the apparent volume, the corporeality, of muscle.

Jeffrey M. Hurwit
historian

ceramic
23½ in (60 cm) high
Staatliche Antikensammlungen und Glyptothek, Munich, Germany

Attic Black-figure Amphora (c.540–30BCE) **Exekias**
Gregorian Etruscan Museum, Vatican City

Phaon and the Daughters of Lesbos (c.410BCE) **Meidias**
Museo Archeologico, Florence, Italy

Mummy Portrait of a Woman

c.100–110 Isidora Master

This portrait—painted by a Greco-Roman artist—is a true depiction of the woman encased within the mummy shroud, but whether it was from life, from the artist's memory, or from descriptions told to the artist by the woman's family is unknown. The luminosity of the color was achieved by the use of encaustic, a mixture of wax and pigments kept malleable by warmth then painted onto the wooden panel. The use of gold leaf suggests a woman of wealth and implies that she was a woman of importance with a dominant personality.

This portrait was painted during the time when the Romans had seized control of Egypt, and it was made to adorn a mummy case made from linen. That the woman's face appears so lifelike is notable for an era in which most art was lacking in dimension and realism. The dominant use of red and the use of thick, heavy black are significant in Egyptian artistic symbolism. Black symbolized both death and the king of the afterlife, Osiris. Red was the color of life and of victory, a suggestion that the woman will defeat death and enter the afterlife. The word "Isidora" is written on the casket, and it is believed to have been the woman's name.

Those persons called 'physiognomists', who prophesy people's future by their countenance, pronounced from their portraits by Apelles either the year of the subject's death or the number of years they had already lived."

Pliny On Apelles

encaustic on linen and wood
19 x 14 x 5 in (48 x 36 x 13 cm)
J. Paul Getty Museum,
Los Angeles, California, USA

Sarcophagus Portrait
(332–95 BCE) **Artist unknown**
Musée du Louvre,
Paris, France,

Mummy Portrait of a Woman
Hawara, Egypt (55–70CE)
Artist unknown
British Museum, London, UK

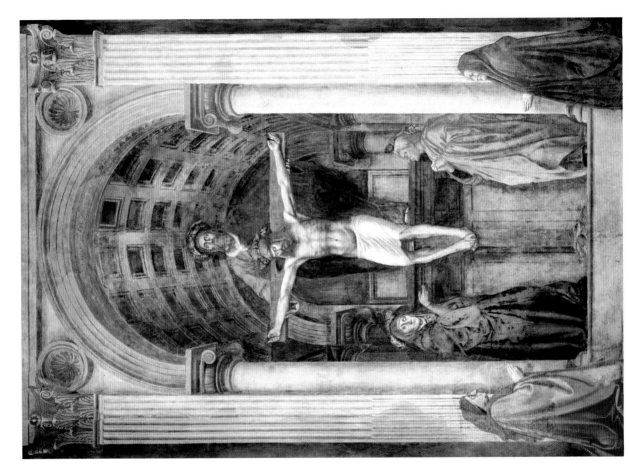

The Holy Trinity 1425–26
Masaccio

The Holy Trinity is the first known painting to have employed with great force the geometry of true linear perspective. It is one of the finest images of the Renaissance—no such convincing realism of forms in space had been made since antiquity. It is astonishing to think that 143 years after its completion, the fresco was considered of such little importance that it was covered by a new altar. The painting was not rediscovered until 1861. On either outer edge, portrayed kneeling with hands clasped as if about to pray and looking face to face across the void, are the two donors who paid for the fresco.

By the age of twenty-six, Masaccio had mastered the art of construction and perspective through conversations with his friend Donatello and the great architect of the time, Brunelleschi, who had researched and experimented with such ideas. Brunelleschi is attributed with teaching Masaccio the necessary means to paint this masterpiece. The sense of realism is heightened by the innovative use of one-point linear perspective, and the trompe l'oeil effect gives the illusion of a genuine barrel-vaulted ceiling. Masaccio's genius was short-lived as he died suddenly, not long after completion of the painting in 1428; it is thought that he might have been poisoned by an artist of lesser talent.

The most beautiful thing, apart from the figures, is the barrel-vaulted ceiling drawn in perspective ... made to recede so skillfully that the surface looks as if it is indented."

Giorgio Vasari
The Lives of the Artists

The School of Athens (1510–11)
Raphael
Vatican Museums and
Galleries, Vatican City

The Last Supper (1495–98)
Leonardo da Vinci
Convent of Santa Maria
delle Grazie, Milan, Italy

fresco
262 ½ x 124 ⅞ in (667 x 317 cm)
Santa Maria Novella,
Florence, Italy

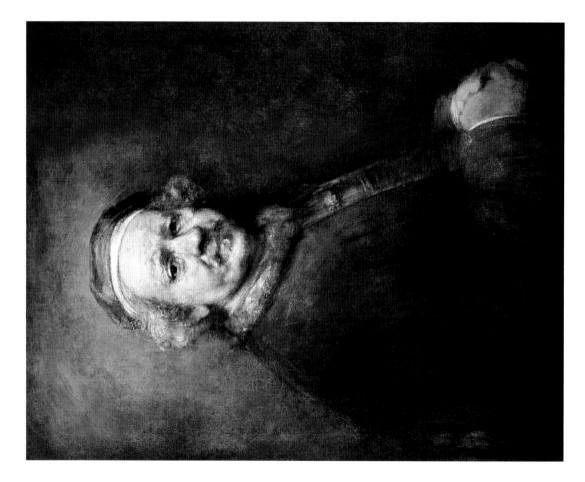

Self-Portrait at the Age of 63 1669
Rembrandt van Rijn

Using only colors from the earth, Rembrandt has conjured up his true self: yellow, red ocher, and umbers make up his palette, with white and black. The light source comes from the left and is modulated through varying temperatures of color (warm ochers, cool grays) and tonal values, represented in terms of planes. These planes articulate the flat picture surface and give the illusion—although they are not illusionistic—that viewers are in the presence of a real person.

Self-Portrait at the Age of 63 was painted during the last year of Rembrandt van Rijn's life, and he worked directly from observation, using a mirror. When looking at the painting, viewers are confronted by a remarkable physical presence. It is as if Rembrandt is still alive, that he is living and occupying the space shown to viewers behind the open window of the picture frame. There is an expanse of space between the solid form of Rembrandt's head and hands. Directly in the viewer's gaze, much closer than the artist's face, is his solid right arm and shoulder. Yet, it is to the face that the eye is drawn. It is as though viewers could actually reach out and squeeze the rather bulbous nose.

Practice what you know, and it will help to make clear what now you do not know."
Rembrandt van Rijn

oil on canvas
33⅞ × 27¾ in (86 × 70.5 cm)
National Gallery,
London, UK

Self-Portrait With Gloves (1498)
Albrecht Dürer
Museo del Prado,
Madrid, Spain

Self-Portrait (1804)
Sir David Wilkie
National Gallery of Scotland,
Edinburgh, UK

Study of the Trunk of an Elm Tree c.1821 John Constable

This nature study is a portrait of a tree; the tree occupies the frame in a similar way to a figure in a portrait painting, and the landscape of the natural world forms the background. The close-up depiction of the bark and the realism of the moss clinging to the trunk's base are elements that would never normally be seen in a landscape painting. Although Constable is best known as a landscape artist, in *Study of the Trunk of an Elm Tree* he employed the techniques he had learned as a portrait painter and created a work of startling realism.

Study of the Trunk of an Elm Tree is an intimate painting, depicted much more realistically than it would have been had it been produced by one of John Constable's near-contemporaries, such as Thomas Gainsborough. Among Constable's richest legacies are his vast studies of clouds, yet although they were impressively realistic (and are still studied by meteorologists today), they seem far more impressionistic in style than *Study of the Trunk of an Elm Tree*. Constable's studies often were much more loosely painted and less "tight" than his completed works, yet this study is uniquely "finished." Despite its small size, the work has been treated as though it were a grand-scale final painting.

When I sit down to make a sketch from nature, the first thing I try to do is to forget that I have ever seen a picture."

John Constable

oil on canvas
Victoria & Albert Museum,
London, UK

The Large Oak Tree (1839)
Theodore Rousseau
Saint Louis Art Museum,
Missouri, USA

The Oak of Flagey (1864)
Gustave Courbet
Murauchi Art Museum,
Tokyo, Japan

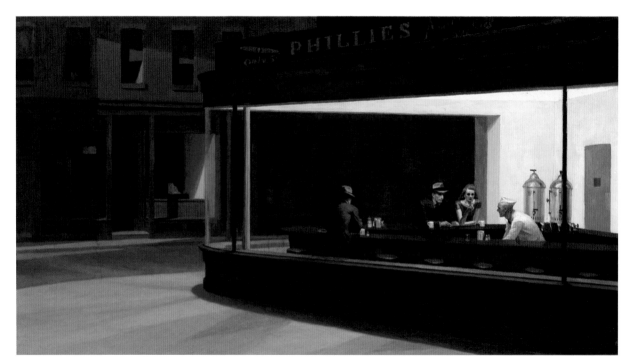

Nighthawks 1942
Edward Hopper

Although Hopper was as a realist painter, *Nighthawks* is more like a graphic illustration or film set than a true street scene; perhaps Hopper was influenced by the then popular genre of film noir. He uses the space to create a physical and emotional distance between his four subjects: even the couple sitting close together seem to be in different worlds from each other, engrossed in their own thoughts. Several small objects, such as the napkin holder and salt and pepper shakers, are rendered in precise detail, adding to the realism of the painting and drawing the viewer further into the scene.

With *Nighthawks*, Edward Hopper was continuing a centuries-old tradition of painting socially realistic scenes. As with so many of his works, Hopper's depiction of urban life in *Nighthawks* emulates—perhaps unconsciously—the works of his socially conscious artistic predecessors, including the British artist William Hogarth, who used his art to make people look properly at the social realities of their day. *Nighthawks* was painted in the year in which Hopper turned sixty, yet this picture is often described as the work that made him "an overnight success." In reality, he had been painting and exhibiting for decades and had sold his first canvas nearly thirty years earlier. This was the painting, however, that made Edward Hopper a recognizable name.

Unconsciously, probably, I was painting the loneliness of a large city."
Edward Hopper

oil on canvas
33 1/8 x 60 in (84 x 152 cm)
Art Institute of Chicago,
Illinois, USA

Shortly After the Marriage (1743)
William Hogarth
National Gallery,
London, UK

American Gothic (1930)
Grant Wood
Art Institute of Chicago,
Illinois, USA

Cut the Line (1944)
Thomas Hart Benton
Navy Art Collection,
Washington, D.C., USA

FORM

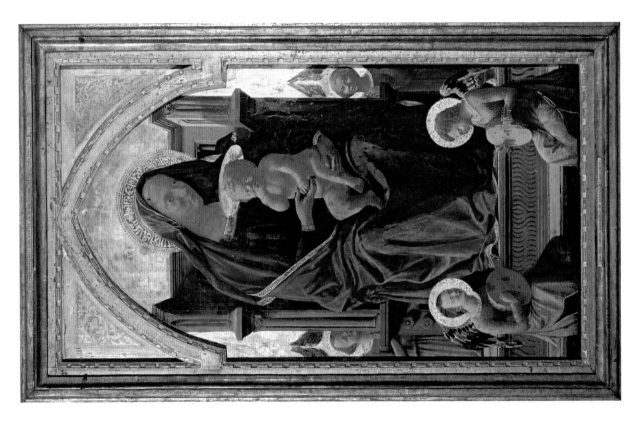

The Virgin and Child 1426
Masaccio

This painting is constructed with the concept of a strong light source coming from the left. The light enables the artist to use chiaroscuro to impart a powerful presence to the figures and a tangible sense of volume to the panel. The Christ child is seated on the Virgin's lap, eating from a bunch of grapes (a reference to the Last Supper. Viewers are equal to the eye level of the two angels at Mary's feet. Although tiny in comparison to the Virgin, they play their lutes in a convincing space, enhanced by the blue of Mary's robe.

The Virgin and Child was created as an altarpiece for a chapel in Pisa, and Masaccio was only twenty-five when he painted it. He was influenced by a fellow contemporary, the sculptor Donatello, from whom he learned to construct the painting's forms with a powerful sense of three-dimensional reality. Masaccio's Virgin Mary, seemingly at ease, is seated on a stone throne of classical influence. It has been drawn in perspective to create a real sense of space—viewers see a true, solid body with weight and gravity. The dignity of form is enhanced by Masaccio having eliminated any unnecessary details from the scene.

I painted, and my picture was like life; I gave my figures movement, passion, soul: They breathed. Thus, all others Buonarroti taught; he learned from me.

Annibal Caro
Epitaph for Masaccio

tempera on panel
53 3/8 x 28 3/4 in (135.5 x 73 cm)
National Gallery,
London, UK

Lamentation of the Death of Christ (c.1304–13)
Giotto di Bondone Capella degli Scrovegni, Padua, Italy

Sistine Madonna (1513–14)
Raphael
Gemäldegalerie,
Dresden, Germany

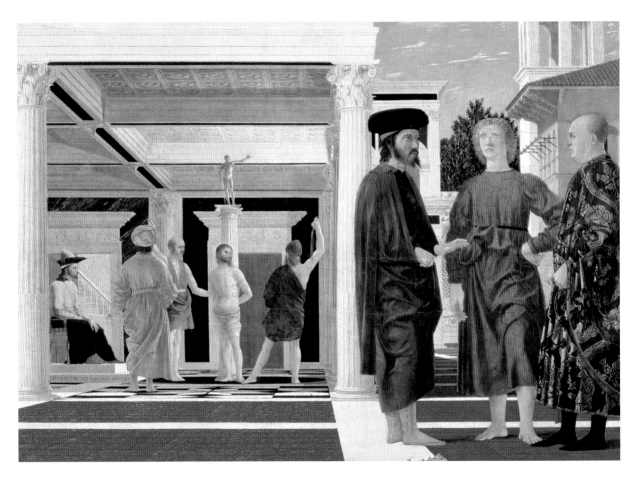

The Flagellation of Christ c.1454
Piero della Francesca

The Flagellation of Christ is structurally divided into two sections. From left to right, the eye first encounters a group of figures in the far distance: Jesus Christ, tied to a pillar; the soldiers who are whipping him; and the seated Pontius Pilate. In the foreground stand three figures separate from, and seemingly oblivious to, the harrowing scene taking place behind them. As the eye moves from background to foreground, a natural separation can be detected; this falls on the Golden Section. The figures in the background are not lost in perspective, and the figures in the foreground are not overly dominant—the balance feels just right.

The knowledge of the Golden Section—also known as the Divine Proportion— goes back as far as the ancient Egyptians. According to legend, in c.350 BCE a Greek mathematician named Eudoxos asked everyone he saw to indicate on a stick held out in front of him the place that they instinctively regarded as the most beautiful on its length. He discovered that the vast majority of people marked the stick in the same place—on what is now known as the Golden Section. Mathematically speaking, the Golden Section is a particular ratio on a given line, whereby the ratio of the entire length of the line to the larger portion of the line is the same as the ratio of the larger portion of the line to the smaller one.

> *Without measurement there can be no art."*
> **Luca Paccioli**
> on Divine Proportion

tempera on panel
23 1/4 x 31 7/8 in (59 x 81 cm)
Galleria Nazionale delle Marche,
Palazzo Ducale, Urbino, Italy

The Mond Crucifixion (1502–03)
Raphael
National Gallery,
London, UK

The Holy Family With the Infant St. John the Baptist and St. Elizabeth (1650–51) **Nicolas Poussin** Fogg Art Museum, USA

The Sacrament of the Last Supper (1955) **Salvador Dalí** National Gallery of Art, Washington, D.C., USA

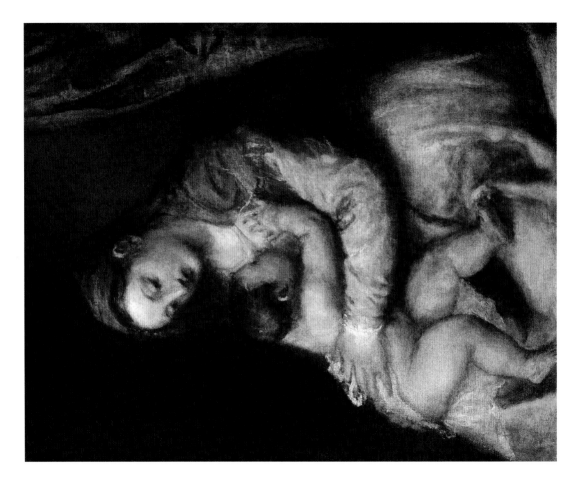

The Virgin Suckling the Infant Christ c.1570–76 Titian

Titian's painting *The Virgin Suckling the Infant Christ* is not merely an illustration but a construction of form made up of planes: surfaces analogous to the two dimensions of the picture plane. These planes are articulated with great robustness and yet great sensibility, too. For example, one plane is the soft-edged rectangular shape representing light on the surface of the child's shoulder. This reads in front of the child's head. From the left side of this same rectangle, viewers travel back to read and discern the far shoulder behind his head.

This tender, beautiful painting is a very late work from the master of Renaissance Venice and may have been in the artist's studio at the time of his death in 1576. The comparatively loose brushwork, when compared to earlier paintings, is characteristic of this period of Titian's work, when the artist was working with greater freedom and a less descriptive portrayal of reality. A soft, sensitive touch is built up over time with the brush as oil paint caresses the canvas with earthy tones, with the exception of the cool blue tint of the Virgin's dress. The overall subtle haze belies the sophistication of the underlying form.

oil on canvas
30 x 25 in (76 x 63.5 cm)
National Gallery,
London, UK

Painting done under pressure by artists without the necessary talent can only give rise to formlessness, as painting is a profession that requires peace of mind."
Titian

Mona Lisa (1503–06)
Leonardo da Vinci
Musée du Louvre,
Paris, France

Woman Bathing in a Stream
(1654) **Rembrandt van Rijn**
National Gallery,
London, UK

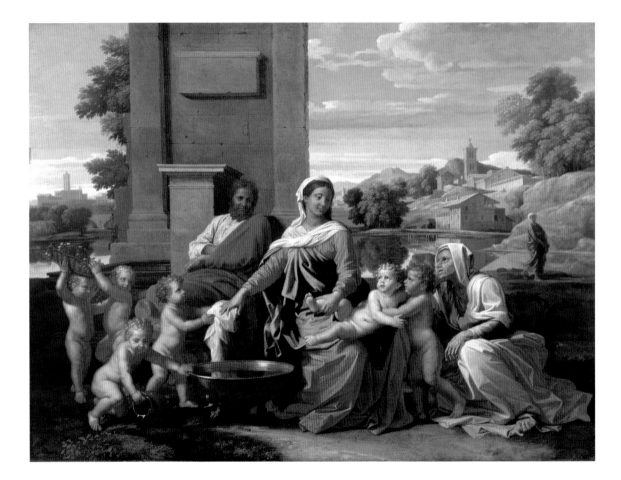

The Holy Family With the Infant St. John the Baptist and St. Elizabeth 1650–51 Nicolas Poussin

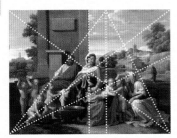

Nicolas Poussin employed a linear logic to this painting, more in keeping with architecture than with painterly design. His use of primary colors dominates the picture, from the vivid red used for the Virgin's dress to the soft yellow of St. Elizabeth's skirts and, most importantly, back to the archetypal blue of the Virgin. This is an innate, intuitional compositional movement, echoing that of the color wheel. A viewer's mind would be naturally drawn to the colors in the order red, yellow, and blue, meaning that the eye is attracted initially to the Virgin, then to St. Elizabeth, and finally back to the Virgin.

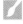

In *The Holy Family With the Infant St. John the Baptist and St. Elizabeth,* the form of the composition is made up of bisected rectangles, triangles, and diagonal lines. The eye can discern a triangle around the family; there are also two strong diagonal "lines" bisecting the picture, with Mary at the apex, where these diagonals meet. The eye is led by the vertical architecture to follow the line down to the Virgin's head. When read from left to right, the Golden Section division lines up with Christ's profile. Viewers can also discern a diagonal line—moving from just beneath the trees on the right to the bottom left corner—which echoes the Christ child's pose.

I feel I have achieved a lot when I paint one head in a day, so long as I achieve my desired effect."
Nicolas Poussin

oil on canvas
39 ⅝ x 52 ⅛ in (100 x 132 cm)
Fogg Art Museum, Harvard
University Art Museums, USA

The Road to Calvary (c.1304–13)
Giotto di Bondone
Cappella degli Scrovegni,
Padua, Italy

The Last Supper (1495–98)
Leonardo da Vinci
Santa Maria delle Grazie,
Milan, Italy

The Golden Stairs (1880)
Edward Burne-Jones
Tate Collection,
London, UK

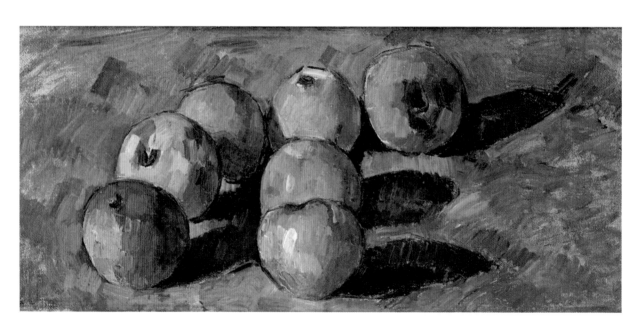

Still Life With Apples 1878
Paul Cézanne

Using differing colors and tones, lights and darks—which describe the individual planes of the apples—Cézanne created an illusion of the apples' solidity and volume within a pictorial depth. In this way, he responded to the light coming from the left as it reflects from the surfaces of the apples and table top. These colored sensations experienced by Cézanne are translated by constructing the equivalent in paint by means of light and dark tones. The paint is applied in harmony with the two dimensions of the canvas with mostly vertical brushstrokes. This appears to carve the picture surface, as though it is a relief made in a slab of marble.

Paul Cézanne's understanding of art was aided by his studies of the Old Masters, and he remained committed to form throughout his career. He imbued his work with a passion for the visual world, and even the humblest of subjects, such as apples, became as majestic as any great religious work. Unlike some of his fellow artists, Cézanne used both color and line to construct form, writing: "I am quite positive—an optical sensation is produced in our visual organs, which allows us to clarify the planes represented by color sensations as light, half-tone, or quarter-tone."

Treat nature by means of the cylinder, the sphere, the cone, everything brought into proper perspective so that each side of an object or a plane is directed toward a central point."

Paul Cézanne

oil on canvas
7 x 14³/₄ in (18 x 37.5 cm)
Private collection

Still Life With Pears (1887–88)
Vincent van Gogh
Gemäldegalerie Neue
Meister, Dresden, Germany

The River Seine at Chatou (1906)
Maurice de Vlaminck
Metropolitan Museum of Art,
New York, USA

Still Life With Pears and Grapes on a Table (1913) **Juan Gris**
Burton Tremaine Collection,
Meriden, Connecticut, USA

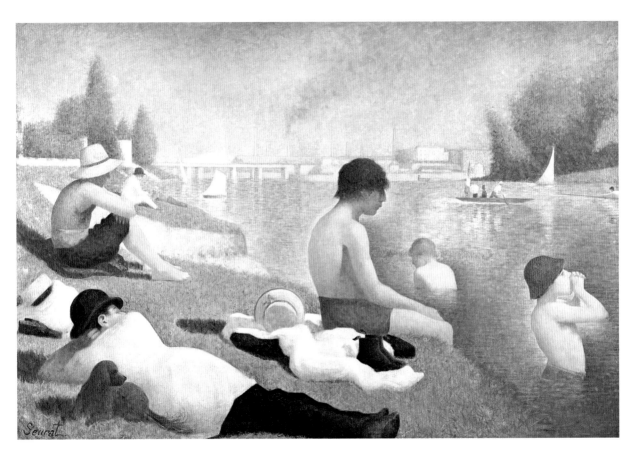

Seurat's method of working resulted in a fine pictorial clarity, which is particularly evident in two working drawings for the reclining foreground figure. Both studies are details of the man's head, shoulders, and part of his back. The first drawing exhibits a detailed study of folds and creases in the man's white jacket; in the second study, *Reclining Man: Study for "Bathers at Asnières"* (1883; left), Seurat has reduced the presence of these creases quite dramatically. The artist's decision to give such clarity to his forms arose from his personal sense of aesthetics and from his love of the clarity of compositions and forms within early Italian Renaissance art.

Georges-Pierre Seurat was only twenty-four years old when he began forming preparatory ideas for his first grand-scale masterpiece, *Bathers at Asnières*. Its large scale was within the academic tradition of the French salon, as was the concept of its form; however, the painting's impressionistic approach was revolutionary. Seurat left fourteen known studies for this work. These are painted, in contrast to the finished painting, on very small wooden panels. Most of the studies were painted in situ, just outside Paris on the left bank of the Seine. In some studies, Seurat concentrated solely on the landscape, whereas in others he worked on the figures. These poses were then re-created in the studio.

They see poetry in what I have done. No. I apply my methods, and that is all there is to it."
Georges-Pierre Seurat

oil on canvas
79 ⅛ x 118 ⅛ in (201 x 300 cm)
National Gallery,
London, UK

The Resurrection of Christ (c.1463)
Piero della Francesca
Pinacoteca Civica,
Sansepolcro, Italy

The Umbrellas (c.1881–86)
Pierre-Auguste Renoir
National Gallery,
London, UK

Breakfast (1886–87)
Paul Signac
Kröller-Müller Museum,
Otterlo, Netherlands

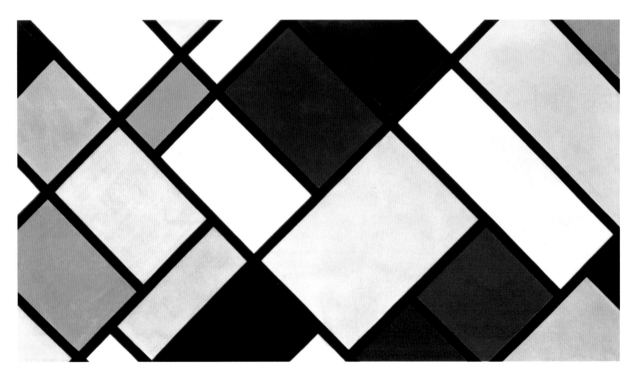

Counter-Composition of Dissonances, XVI 1925
Theo van Doesburg

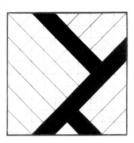

Like other members of the De Stijl movement, van Doesburg eschewed the use of any colors except the primary colors—red, yellow, and blue—or the "noncolors" of black, white, and gray—seen in *Counter-Composition VI* (1925; left). This strips painting right back to its essence, its most basic formal elements. In his series of *Counter-Composition* paintings, the artist concentrated on lines and color contrasts, emphasizing the dynamic tension created by the use of diagonal lines. Van Doesburg's observations regarding the use of diagonals were ahead of their time, because it is was only in the 1990s that neurologists discovered that certain parts of the brain react differently to diagonals in comparison to verticals.

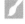

Theo van Doesburg was inspired by natural forms, but his work is not defined by figures, buildings, or trees, but by the geometric placing of similarly inspired concepts. He composed this painting almost entirely of diagonals because he believed that diagonals were more forceful and more rhythmic than the vertical and horizontal lines favored by his De Stijl stablemate Piet Mondrian. The two artists fell out because of an artistic difference regarding the use of diagonals: Mondrian despised them and refused to use them. *Counter-Composition of Dissonances, XVI* could be said to be a Mondrian composition tilted to one side.

Each superfluous line, each wrongly placed line, any color placed without veneration or care, can spoil everything— that is, the spiritual."
Theo van Doesburg

oil on canvas
39 3/8 x 70 7/8 in (100 x 180 cm)
Gemeente museum den Haag,
The Hague, Netherlands

Composition (1918)
Bart van der Leck
Tate Collection,
London, UK

Tableau 1 With Red Black Blue and Yellow (1921) **Piet Mondrian**
Gemeente museum den Haag,
The Hague, Netherlands

Composition (1955–60)
Vilmos Huszar
Private collection

Studio V 1949–50
Georges Braque

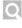

Studio V is a highly personal and sensitive reaction to the world around its artist, and it is the nature of this response that makes Braque so fascinating. His world is a recognizable real world—the artist's palette, the graphic nature of grainy wood, a goldfish bowl, the image of a bird—and yet viewers can acknowledge the abstract nature of his work as an abstraction and a work of artifice, too: it is one and yet both simultaneously. Braque's achievement is analogous to the great late work of the Venetian master Titian in the way that they both created sublime works of pictorial genius.

This painting belongs to a series of late works based on the motif of depicting objects within the space of the artist's studio. The language employed is a development from cubism—synthetic cubism—of which Georges Braque and Pablo Picasso were pioneers. Braque's chief concern in *Studio V* was for the concept of pictorial space: he believed that there should be as much form to the painting of the void as there is to the depicted forms themselves.

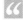

You see, I have made a great discovery. I no longer believe in anything. Objects don't exist for me, except in so far as a rapport exists between them or between myself. . . . Life then becomes a perpetual revelation. That is true poetry."

Georges Braque

oil on canvas
57 7/8 x 69 1/2 in (147 x 176.5 cm)
Museum of Modern Art,
New York, USA

Nude Descending a Staircase, No. 2 (1912) **Marcel Duchamp**
Philadelphia Museum of Art,
Pennsylvania, USA

Fantômas (1915)
Juan Gris
National Gallery of Art,
Washington, D.C., USA

Three Musicians (1921)
Pablo Picasso
Museum of Modern Art,
New York, USA

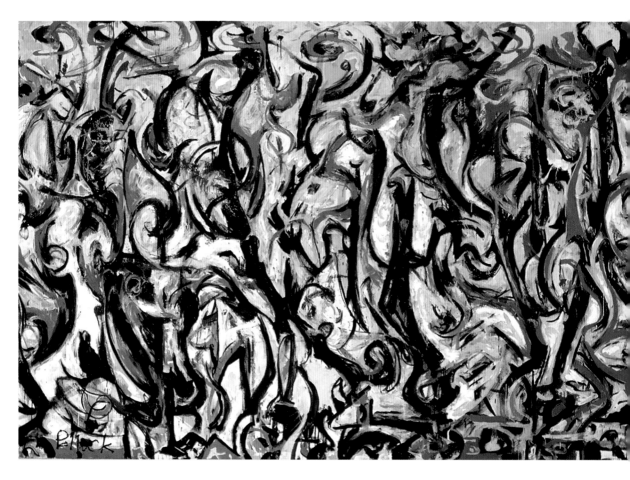

MOVEMENT

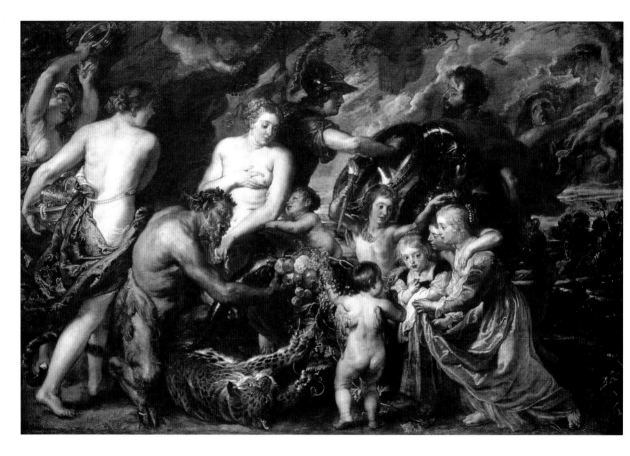

Minerva Protects Pax from Mars (Peace and War)

1629–30 Sir Peter Paul Rubens

In the West, paintings are "read" from left to right, so as viewers enter the painting from the left-hand side, the movement engendered by the figure of the woman on the far left pushes their gaze up into the scene. This is echoed in the draperies that work the eye right up to the top. All elements seem to be drawing attention up to the top right, but this is counterbalanced by the swirling brushstrokes in that top corner, which lead the eye back down to the figures of the children in the foreground. The postures and draperies of the children direct the gaze to the central figures of Peace (or Pax) and the warriorlike Minerva, goddess of wisdom.

The title of this painting is not only indicative of the content; it is also a political statement. Peter Paul Rubens was an envoy to King Philip IV of Spain, and he gave this painting to the English King Charles I in a bid to negotiate peace between the two countries. The painting is filled with movement, the success of which is due to the fact that it is never-ending, leading the eye from one part of the canvas to another and back again. Rubens directs the viewer in a similar manner to the way in which a camera pans across a cinematic scene.

[Rubens was a] widely traveled and confident man of the world, valued in most of the courts of Europe as a superb and prolific painter and as an expert on all aesthetic questions: a man who shone in any society."

C. V. Wedgwood historian

oil on canvas
80 1/8 x 117 3/8 in (203.5 x 298 cm)
National Gallery,
London, UK

Bacchus and Ariadne
(1520–33) **Titian**
National Gallery,
London, UK

The Crossing of the Red Sea
(c.1634) **Nicolas Poussin**
National Gallery of Victoria,
Melbourne, Australia

Work (1865)
Ford Madox Brown
Manchester City Art Galleries,
Manchester, UK

Artisans Making a Woodcut c.1803
Utamaro Kitagawa

Artisans Making a Woodcut is an artwork produced by a printing technique that is demonstrated within the image itself, a colored woodcut. Blocks of hardwood are used for each color, and most commonly a limited number are chosen. The areas that are not to be printed are cut away; the ink is then applied with a roller onto the relief and printed from a press with vertical pressure. Viewers observe the diptych in a sequence: the cutting and preparation of the blocks is depicted in the left-hand panel; the narrative then moves into the second panel, in which the final printing process has already taken place and the woodcut itself is displayed.

The design and color in *Artisans Making a Woodcut* orchestrate the sensation of movement within the busy workshop, as the chosen colors are repeated and the viewer's eye is persuaded to move back and forth in a rhythm. This print was made approximately fifty years before Japan would forcibly open its ports, in 1854, and trading would start again with the West. Everything Japanese became of great significance, and Japanese prints were extremely influential on the aestheticists, Impressionists, and post-Impressionists. They were inspired by the prints' subject matter, such as this image of the everyday worker, and influenced by the graphic nature of compositions that contained such a powerful sense of schematic design.

Art is the illusion of spontaneity."
Utagawa Kunisada

colored woodcut
Art Institute of Chicago,
Illinois, USA

Fifty-three Stations of the Tokaido Highway (c.1834)
Utagawa Hiroshige Brooklyn Museum of Art, New York, USA

The Dance Class (c.1874)
Edgar Degas
Musée d'Orsay,
Paris, France

Circus (1891)
Georges-Pierre Seurat
Musée d'Orsay,
Paris, France

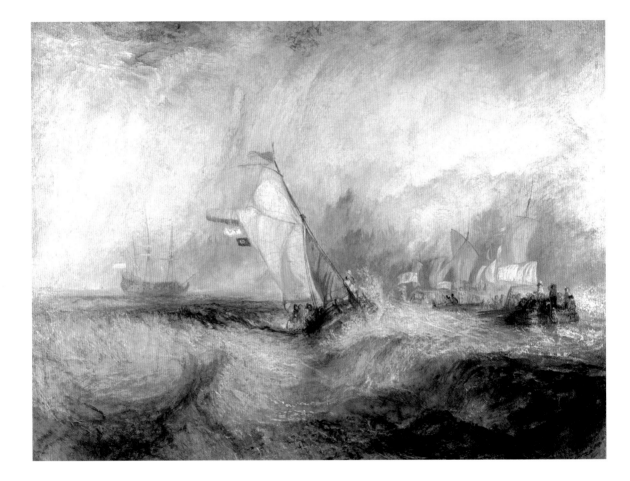

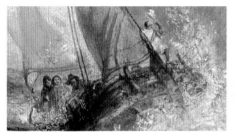

The sickly gray-green color of the rough and turbulent seas compels viewers to imagine how seasick a sailor might feel, trapped onboard a huge ship as it lumbers and pitches against the rhythm of the waves. According to rumor, Turner once asked a mariner to lash him to a mast during a snowstorm so he could experience the true power of the sea. Turner expressed the same concept in *Snow Storm—Steam-Boat off a Harbour's Mouth* (c.1842), in which the storm seems to be reaching so far beyond the painting's edge that it is swirling off the canvas.

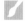

J. M. W. Turner was as famous for his seascapes as he was for his landscapes, and in this painting he uses a primary-based palette to re-create an astonishingly atmospheric scene. He uses short, expressive brushstrokes to render the storm clouds and thick white paint to depict the crashing of the huge waves. The van Tromp of the painting's title was the Dutch master mariner Cornelis van Tromp, who, at the age of nineteen, had been given command of an entire squadron; he went on to earn glory during many years of battle before being discharged for "undisciplined behavior." Turner demonstrates van Tromp's bravery and skill in keeping his squadron of ships afloat despite the turbulent sea.

I don't paint so that people will understand me, I paint to show what a particular scene looks like."

J. M. W. Turner

oil on canvas
35 3/4 x 48 in (91 x 122 cm)
J. Paul Getty Museum,
Los Angeles, California, USA

The Storm on the Sea of Galilee (1633)
Rembrandt van Rijn
Stolen

Waves (1869)
Gustave Courbet
Philadelphia Museum of Art,
Pennsylvania, USA

Summer Squall (1904)
Winslow Homer
Sterling and Francine Clark Art
Institute, Massachusetts, USA

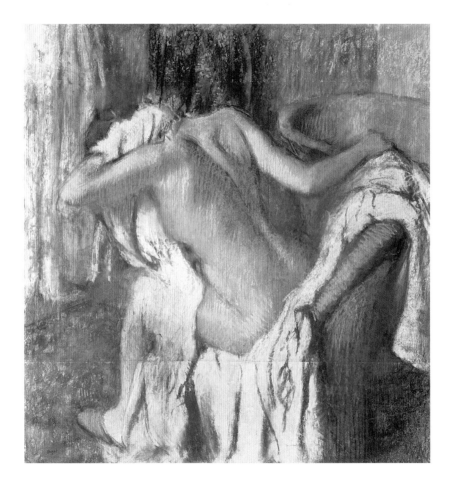

After the Bath, Woman Drying Herself 1890–95
Edgar Degas

Degas's interest in capturing a perfect moment in movement comes from his fascination with photography and in particular with the pioneering work of Eadweard Muybridge. Many Degas paintings are deliberately composed of figures being "cut off," either caught entering or exiting a scene, as though the painting process was as immediate as the taking of a photograph. In *After the Bath, Woman Drying Herself*, the implied movement is heightened by Degas rubbing out the near arm and elbow, in order to imply the shudder of the arm in movement. Was Degas thinking of the "blur" of a photograph?

Much of Edgar Degas's work is voyeuristic. Some of his most famous pieces are of ballerinas in their most intimate moments, but Degas was also fascinated by the subject of women washing themselves. In this painting, the woman is almost feline in her movements, as though she were a cat preening. Degas found it hard to contain his ideas within the original sheet of paper and often needed to add extra pieces; this picture is composed of seven different sizes of paper.

I assure you no art was ever less spontaneous than mine. What I do is the result of reflection and study of the great masters; of inspiration, spontaneity, temperament—temperament is the word —I know nothing."

Edgar Degas

pastel on wove paper laid
on millboard
41 x 38 ³/₄ in (104 x 98.5 cm)
National Gallery, London, UK

The Sower (1850)
Jean-François Millet
Museum of Fine Arts, Boston,
Massachusetts, USA

Woman at Her Toilette (c.1875)
Berthe Morisot
Art Institute of Chicago,
Illinois, USA

The Child's Bath (1893)
Mary Cassatt
Art Institute of Chicago,
Illinois, USA

Nude Descending a Staircase,
No. 2 1912 Marcel Duchamp

Nude Descending a Staircase, No. 2 combines the fragmentary style of cubism with the energetic movement of futurism. Duchamp was inspired by Eadweard Muybridge's photography, with its multiple reproductions of the same image milliseconds apart, as seen in Muybridge's series of images of a horse in motion (left). In this painting Duchamp also used a "multiple-exposure" technique: the repetition of the same figure to denote one nude figure caught in motion walking down a staircase.

This futuristic depiction of the human body, seemingly a true inhabitant of the machine age, encapsulates Marcel Duchamp's attempts to represent three dimensions in motion. The painting was decades ahead of its time, as demonstrated by the shock shown by many members of the public seeing it for the first time at New York City's Armory Show. Initially, Duchamp had sent the painting to the Salon des Independents in Paris, but the hanging committee—which included two of his own brothers—refused it for its main exhibition. They told him that the decision had been made because "a nude never descends the stairs—a nude reclines."

> *If a shadow is a two-dimensional projection of the three-dimensional world, then the three-dimensional world as we know it is the projection of the four-dimensional Universe."*
>
> Marcel Duchamp

oil on canvas
57⅞ x 35⅛ in (147 x 89 cm)
Philadelphia Museum of Art,
Pennsylvania, USA

Speeding Automobile (1912)
Giacomo Balla
Museum of Modern Art,
New York, USA

Dynamism of a Cyclist (1913)
Umberto Boccioni
Private collection

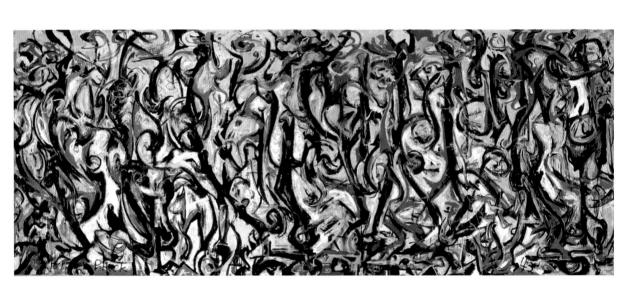

Mural 1943
Jackson Pollock

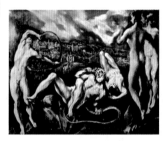

Pollock had many artistic influences. He often drew from Old Masters and was particularly inspired by the mannerist paintings of El Greco, such as *Laocoön* (c.1610–14; left). With *Mural*, Pollock melded dozens of his influences, making the work at once figurative and surreal with elements of landscape painting. What at first glimpse seems to be a sinuous pattern of curvaceous lines is revealed, on closer inspection, to be filled with standing, leaning, and stretching figures—animalistic and human—that dominate the canvas from top to bottom, sweeping the viewer's eye vertically and horizontally across the space.

In *Mural,* abstract expressionist artist Jackson Pollock evoked both the distortions of El Greco and the newfound freedom embraced by Pablo Picasso. Key to understanding Pollock's work is the realization that he always remained a figurative painter. *Mural* is imbued with figures taking part in a frenzied dance in a frenetic landscape. The movement and rhythm can be compared to the greatest of the Renaissance masters. The schematic design of Michelangelo's ceiling of the Sistine Chapel is evoked in the energy and movement of Pollock's *Mural*.

A stampede … [of] every animal in the American West, cows and horses and antelopes and buffaloes. Everything is charging across that goddamn surface."

Jackson Pollock on *Mural*

oil on canvas
97 x 238 in (247 x 605 cm)
University of Iowa Museum
of Art, Iowa, USA

*Christ Driving the Traders
from the Temple* (c.1600)
El Greco
National Gallery, London, UK

Guernica (1937)
Pablo Picasso
Museo Reina Sofía,
Madrid, Spain

Mountains and Sea (1952)
Helen Frankenthaler
National Gallery of Art,
Washington, D.C., USA

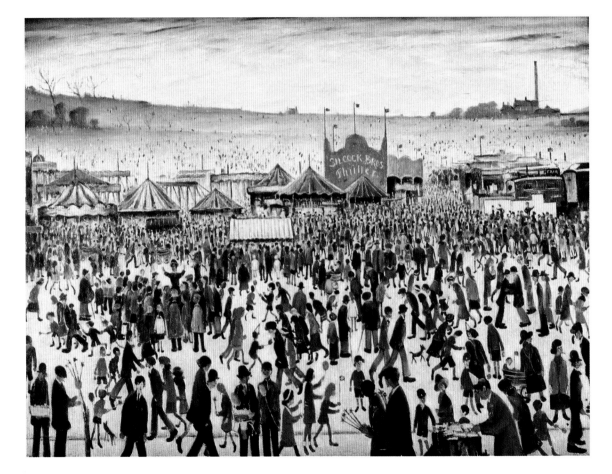

Good Friday, Daisy Nook 1946
L. S. Lowry

Lowry is often thought of as a naive artist, yet this is a sophisticated work of geometric precision and poetry in which the animated figures moving around the space are beautifully organized. The scale of the figures relating to their surrounding spaces at the front gives a sense of perspective; farther back in the composition, the spaces disappear. If Lowry had used shadows, the painting would be a confused mess; there would be no white space, and the pictorial image would be lost. He experimented with different whites and thought his painting would look better twenty years later because the whites would have changed in tone.

L. S. Lowry's crowd of figures is a melting pot of people milling around—excited and purposeful—and looking at this picture places the viewer at the center of the scene. Lowry had a masterful understanding of the properties of color and used a deliberately limited palette—black, white, and the primary colors of yellow ocher, Prussian blue, and vermilion red—to create an animated scene of intense richness and vibrancy.

Now they said his works of art were dull
No room, all round the walls are full
But Lowry didn't care much anyway
They said he just paints cats and dogs
And matchstalk men in boots and clogs."

Burke and Coleman lyrics from "Matchstalk Men and Matchstalk Cats and Dogs"

oil on canvas
28 1/2 x 36 1/4 in (72 x 92 cm)
Government Art Collection,
London, UK

Garden of Earthly Delights (c.1504)
Hieronymus Bosch
Museo del Prado,
Madrid, Spain

The Hunters in the Snow (1565)
Pieter Bruegel the Elder
Kunsthistorisches Museum,
Vienna, Austria

Boulevard Montmartre (1897)
Camille Pissarro
Private collection

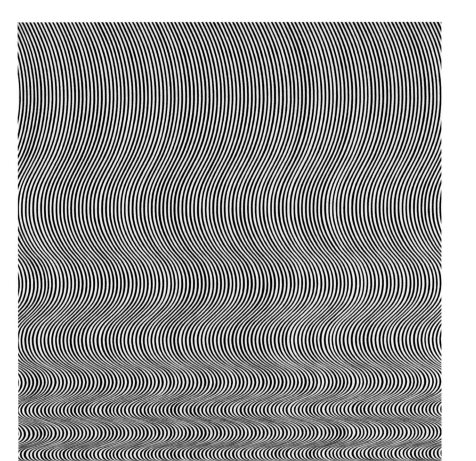

Fall 1963
Bridget Riley

The relationship between the individual lines creates the energy in this work: the big curves turn into the smaller curves, and that relationship creates the sensation of movement. *Fall* plays upon the unique visual relationship of what happens when a viewer looks at a work of art and what image that work creates in their own head. In the twenty-first century, Riley has created abstract paintings about color relationships, such as the interplay of light falling on leaves. In *Fall* she is looking at the relationship between black and white—which is the positive space here and which is the negative? Are the true lines in *Fall* composed of black or white?

A perfect example of op art (optical art), Bridget Riley's *Fall* deliberately confuses the eye, its curves giving the illusion of a relief sculpture jutting out in waves from the canvas. The pattern of the curves produces a sensation of movement, which is intensified as the eye moves to the bottom of the painting, where the curves are increasingly compressed. Riley related everything to the observed world, to nature, to the world around her, and *Fall* is about the relationship between viewers and the world around them. Central to the painting is the concept of turning the visual world of nature into the visual world of op art. *Fall* is not trying to illustrate a wave or a waterfall, for example; here, Riley is illustrating the very concept of nature.

I try to organize a field of visual energy which accumulates until it reaches maximum tension."
Bridget Riley

emulsion on hardboard
55 ½ x 55 in (141 x 140 cm)
Tate Collection, London, UK

Vega (1957)
Victor Vasarely

Occhio al Movimento (1964)
Alberto Biasi

Many Notes (1990)
Julian Stanczak

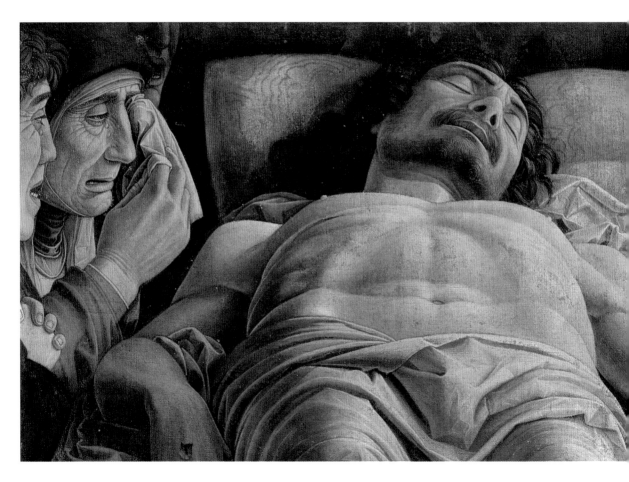

DISTORTION

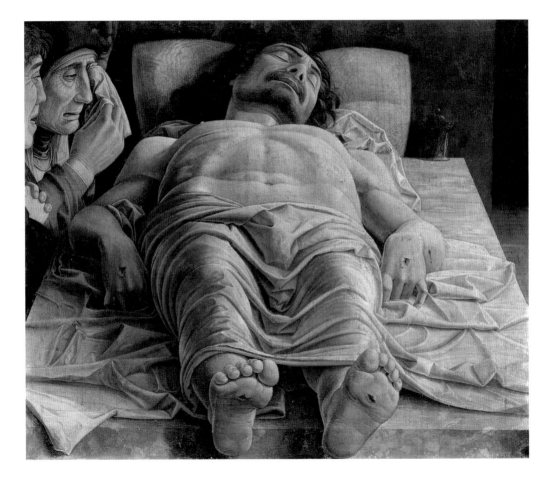

The Lamentation Over the Dead Christ *c.*1480
Andrea Mantegna

Mantegna articulated the foreshortening in *The Lamentation Over the Dead Christ* by changing the proportions of the body, reversing them in such a way that primarily the viewer would be drawn to look at Christ's head. In this way the viewer is involved with the pathos of the scene: Christ's mother's grief. This technique also prevents the viewer from dwelling on Christ's feet, which are in the foreground, and has the effect of flattening the picture space (constructing an almost sculptural shallow relief). By lessening the otherwise overdramatic violence of foreshortening, the artist gives the viewer a gentle entry into the picture space—a place that allows for quiet contemplation.

Andrea Mantegna's portrayal of the dead Christ remains groundbreaking because, with this painting, the artist broke the laws of linear perspective. In the previous decade, he had completed a fresco cycle in the Palazzo Ducale in Mantua, and this influential ceiling oculus shows figures and architecture in perfect perspectival foreshortening. So why did Mantegna break these same perspectival laws in *The Lamentation Over the Dead Christ*? He did so because he truly understood perspective and therefore was equipped to distort it in order to create a greater effect than a perspectively true painting would have achieved.

I have observed it to be well-nigh a common fact in men that the length of the foot is the same as the distance from the chin to the top of the head."

Leon Battista Alberti *On Painting*

distemper on canvas
27 x 32 in (68 x 81 cm)
Pinacoteca di Brera, Milan, Italy

Sistine Chapel Ceiling (1508–11)
Michelangelo
Apostolic Palace,
Vatican City

The Ambassadors (1533)
Hans Holbein the Younger
National Gallery,
London, UK

Supper at Emmaus (1601)
Caravaggio
National Gallery,
London, UK

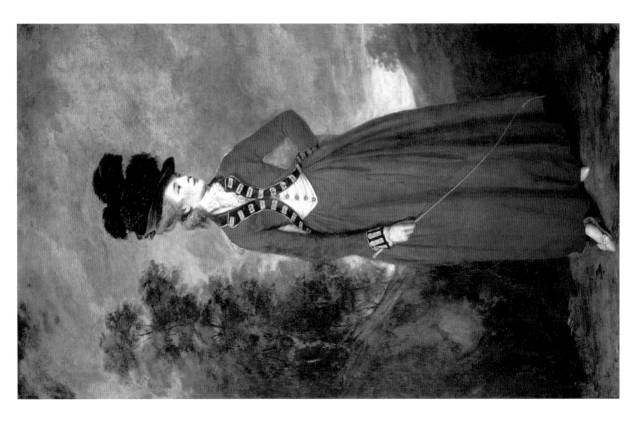

Lady Worsley c.1776
Sir Joshua Reynolds

This painting was exhibited just two years before its subject became embroiled in one of the most scandalous court cases of the eighteenth century. Sir Joshua Reynolds, well aware of Lady Worsley's reputation, painted her as sexually alluring and dominant (note the riding crop). He used distortion to emphasize a certain grandeur and beauty, an idea influenced by his knowledge of Renaissance painting (particularly Titian's distortions of the female form). The extra-long proportions of her legs and the tiny scale of her feet—related to the size of her head—would make it very difficult for the real Lady Worsley to stand upright.

Reynolds clearly intended this portrait to make a strong impression, and his use of an uncharacteristic softly painted background makes his subject stand out dramatically. It also gives Lady Worsley an air of great confidence and grandeur. Her spectacular red riding costume was based on her husband's regimental uniform and was created to make the most of her figure, emphasizing her waist. Despite the riding costume and crop, Lady Worsley's fashionable shoes show that the subject is dressed to impress, not for sport.

As they departed at breakneck speed for the capital, their chaise passed directly in front of Sir Richard's darkened bedroom window, leaving a jangle of noise in its wake."

Hallie Rubenhold
Lady Worsley's Whim

oil on canvas
93 x 56 1/4 in (236 x 144 cm)
Harewood House,
Yorkshire, UK

Portrait of Dona Margarita de Cardona (16th century) **Titian**
Lobkowicz Collections,
Nelahozeves Castle, Czech Rep.

Madame de Pompadour (1758)
François Boucher
Victoria & Albert Museum,
London, UK

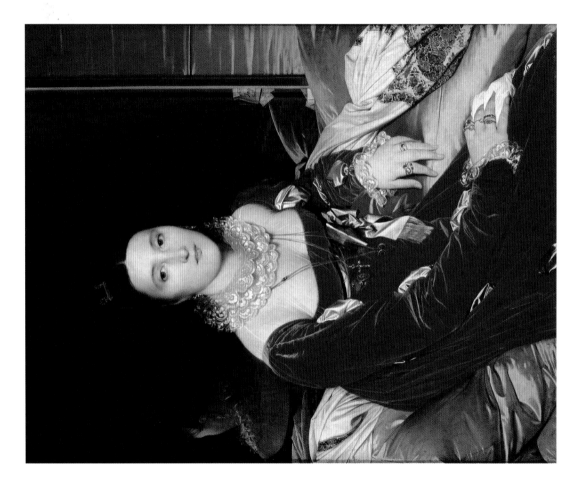

Madame de Senonnes 1814
Jean-Auguste-Dominique Ingres

For Ingres, "getting it right" was not a matter of anatomical correctness. The proportion of Madame de Senonnes's sweeping right arm is distorted, yet it is right for the picture in two ways. First, the extra length allows for the arm, from the wrist, to move gently back in depth spatially. When related to her head, this gives the illusion of the head projecting forward, thus heightening the viewer's focus on her face. Second, the positioning of the hand within the composition would not work as harmoniously if it were ruled by fact rather than by artistic intuition.

Jean-Auguste-Dominique Ingres's magnificent portrait was painted when he was only thirty-four, and during the same period as the *La Grande Odalisque* (1814). The artist's main desire throughout his life was to paint grand history paintings, but for financial reasons he was forced to accept portrait commissions that he resented having to make. Despite this, Ingres's painting was not rushed, and his working style was meticulous. He made many preparatory drawings for the painting: studies of the composition, pose, varying postures, and clothing. Later in life he advised the young Edgar Degas to "draw lines young man, draw lines"; this was something Ingres had pursued until he got it right.

> *An arm so marvellously painted can never be long enough."*
> **Max Liebermann**

oil on canvas
41 ¾ x 33 in (106 x 84 cm)
Musée des Beaux-Arts,
Nantes, France

Madonna of the Long Neck
(c.1535) **Parmigianino**
Galleria degli Uffizi,
Florence, Italy

Andromeda (1927–29)
Tamara de Lempicka
Private collection

Les Demoiselles d'Avignon 1907
Pablo Picasso

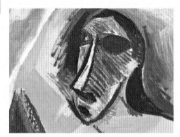

Picasso's painting of prostitutes in a brothel shocked the art world, not only with its radical subject matter, but also with the artist's use of such a "primitive" style. Picasso was influenced strongly by African art and masks—two of which appear in this painting—and his use of geometric forms was startlingly modern. *Les Desmoiselles d'Avignon* was Picasso's attempt to put African art into a Western artistic concept. The painting was also an homage to the work of Paul Cézanne, in particular his *Grand Bathers* (1906). Picasso believed that the world was not yet ready for the painting he had titled *The Brothel at Avignon*. He was right.

Initially, *Les Desmoiselles d'Avignon* was derided as distorted and immoral; Picasso was accused of cheating the public and of having no talent. Yet hours of planning and preparatory sketching had gone into creating this painting. As Picasso famously commented in later life, at the age of fifteen he could paint like Velázquez, but it took him eighty years to be able to paint like a child. With *Les Desmoiselles d'Avignon,* he was moving out of the realms of the norms of figurative art and choosing to use deliberate distortion. The painting marked the beginning of modernism and cubism; it also presaged Picasso's role as a leader of the upcoming surrealist movement.

Les Demoiselles d'Avignon *is the rift, the break that divides past and future. Culturally, the twentieth century began in 1907."*

Jonathan Jones *Guardian*

oil on canvas
96 x 92 in (244 x 234 cm)
Museum of Modern Art,
New York, USA

The Young Sailor (1906)
Henri Matisse
Metropolitan Museum of Art,
New York, USA

Houses at L'Estaque (1908)
Georges Braque
Kunstmuseum, Basel,
Switzerland

Portrait of Picasso (1912)
Juan Gris
Art Institute of Chicago,
Illinois, USA

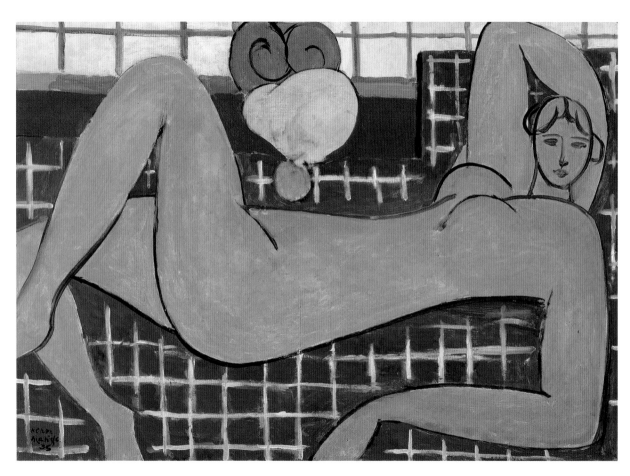

Large Reclining Nude (The Pink Nude) 1935
Henri Matisse

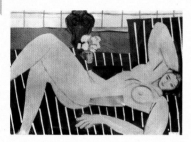

There are twenty-two known photographs of stages of progress for *Large Reclining Nude*, such as "Stage No. 9" (left). These showed the artist whether he was getting closer to or further away from his original idea. The early photographs show a painting that viewers might call lifelike. It then goes through a point of departure from the actual image observed, yet the model claimed, "My pose didn't change." The departure was by no means an easy one, and the journey was not linear; Matisse experimented with painted forms and cutouts of colored paper. Toward the end of his career, paper cutouts featured in Matisse's monumental collages.

Large Reclining Nude is not a large painting, yet it is monumental in presence and took six months to complete. The model is Lydia Delectorskaya, who had been Henri Matisse's assistant on *Dance* (1933). The image may be distorted, yet it expresses the artist's inner subconscious—his feeling for his subject—and it is all importantly imbued with his formal ideas of art. Matisse liked to work directly from a model and commented: "If there were no model, one would have nothing from which to deviate."

> *I replied to someone who said I didn't see women as I represented them: 'If I met such women in the street, I should run away in terror.' Above all, I do not create a woman, I make a picture."*
>
> **Henri Matisse**

oil on canvas
26 x 36¼ in (66 x 92 cm)
Baltimore Museum of Art,
Maryland, USA

La Grande Odalisque (1814)
Jean-Auguste-Dominique Ingres
Musée du Louvre,
Paris, France

Reclining Nude (1917)
Amedeo Modigliani
Private collection

Blue Nude III (1952–53)
Henri Matisse
Musée National d'Art Moderne,
Paris, France

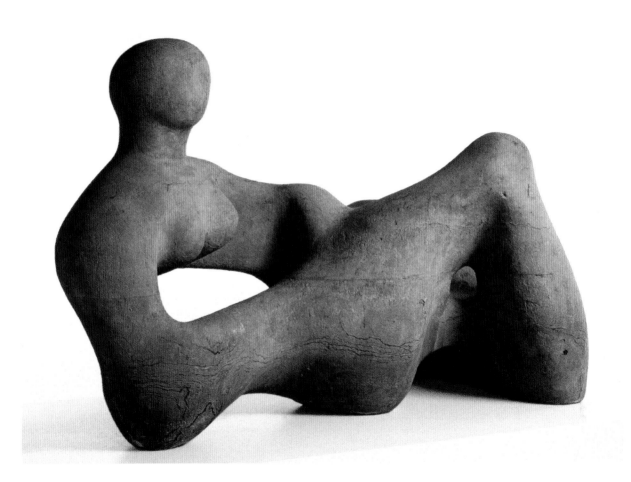

Recumbent Figure 1938
Henry Moore

Moore examined and collected pebbles, shells, driftwood, and bones, and made drawings that transformed their organic shapes into human form. He frequently used sea-worn pebbles as the starting point of stone sculptures, and in *Recumbent Figure* the smoothly modulated curves, with a carved hole in the center, mimic the effect of the sea on a pebble. *Recumbent Figure* was originally commissioned to stand outdoors overlooking the Sussex downs in the south of England, and the sculpture appears to relate to the form of the landscape itself. Moore was always keen to work with local materials, and the Hornton stone used in this piece originated from a quarry near Banbury in Oxfordshire.

The human form has often been distorted in art for expressive purposes, and *Recumbent Figure* is a notable example of this concept. As the viewer wanders around the work, the eye deciphers the artist's simple, sometimes perplexing, shapes as basic elements of the human figure, some of which only take on their human form when viewed from a particular angle. Henry Moore's central concern was to create an elemental, living image through natural materials: one that would remind the viewer that this flowing form was once a block of solid stone.

I wanted to believe that I could carve the shape I wanted without copying it. . . . I like the fact that I begin with the block and have to find the sculpture that's inside it."

Henry Moore

Green Hornton stone
35 x 52 x 29 in
(89 x 132.5 x 73.5 cm)
Tate Collection, London, UK

Mademoiselle Pogany (1912)
Constantin Brancusi
Philadelphia Museum of Art,
Pennsylvania, USA

Woman With Her Throat Cut
(1932) **Alberto Giacometti**
Museum of Modern Art,
New York, USA

Hollow Form (Penwith) (1955–56)
Barbara Hepworth
Museum of Modern Art,
New York, USA

Study for Homage to the Square 1956
Josef Albers

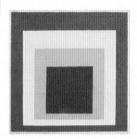

In *Study for Homage to the Square,* Albers used a palette knife to paint with oil onto a masonite panel. He began with smaller studies then enlarged their scale in order to observe the illusory effects of the increase in surface area of color. The distortions and illusions that were observed led Albers to further study the interaction of color. He discovered that the experience of viewing an expanse of color is very different from looking at a tiny sample, and anyone who has chosen paint at a DIY shop from a color chart will understand how disappointing the final result can sometimes be. In *Study for Homage to the Square: Still Remembered* (1954–56; left) the light colors make their neighboring colors look darker, and vice versa.

This painting is one of a large series of works titled *Homage to the Square,* in which Josef Albers explored the interaction of color in a series of concentric flat squares. He began the series in 1949 and continued until his death in 1976. An artist and teacher, he had been part of the famous Bauhaus in 1920s Germany before arriving in the United States in 1933. There he taught at a college before leading the department of design at Yale University. It was during his eight years at Yale that he painted *Study for Homage to the Square.* Albers's experience as a teacher is essential to his work as an artist. This is evident in his book *Interaction of Color* (1963), which is a visual, practical study of the phenomenon of color.

> *He who claims to see colors independent of their illusionary changes fools only himself, and no one else."*
>
> **Josef Albers**

oil on masonite
17³⁄₄ x 17³⁄₄ in (45 x 45 cm)
Private collection

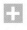

Composition VIII (The Cow) (c.1918)
Theo van Doesburg
Museum of Modern Art,
New York, USA

With Respect to Albers (1957)
Julian Stanczak
Private collection

Deep Magenta Square (1978)
Richard Anuszkiewicz
Private collection

Annette in the Studio 1961

Alberto Giacometti

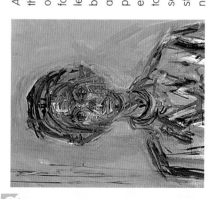

Annette in the Studio is a painting "about" the visual physical presence and experience of a figure in space—a concept that reaches far back into antiquity. The forms of Annette's legs and feet are close by, and viewers travel back spatially in depth to her hands and torso and finally back to her head. The distance portrayed between knees and head appears exaggerated, with the latter seemingly to hover behind her shoulders. Around the seated Annette, in a corner of the artist's studio, are a bed, scattered sheets of newspapers, and stacked canvases.

Alberto Giacometti used his wife as a model for both painting and sculpture. This work is not a portrait in the conventional sense, but rather a drawing in paint, mostly monochrome but for a warm area of ocher within the far wall. Giacometti painted his wife from a seated position, and traditional perspective is distorted radically because he constructed his forms relative to each other. The tip of the nose is only slightly in front of the face, but the distance between the face and knees is comparatively vast. With this perceived concept, distortion will occur.

> *To see better, to understand better what is happening around me; to be as free and as substantial as possible in whatever I do; to pursue my experience; to discover new worlds; to fight my battles—for pleasure? Out of joy?"*
>
> **Alberto Giacometti**

oil on canvas
53 1/2 x 38 1/8 in (136 x 97 cm)
Hamburger Kunsthalle,
Hamburg, Germany

Nude Boy and Girl on the Shore (1913) **Ernst Ludwig Kirchner** R & H Batliner Art Foundation, Salzburg, Austria

J.Y.M. Seated No. 1 (1981) **Frank Auerbach** Tate Collection, London, UK

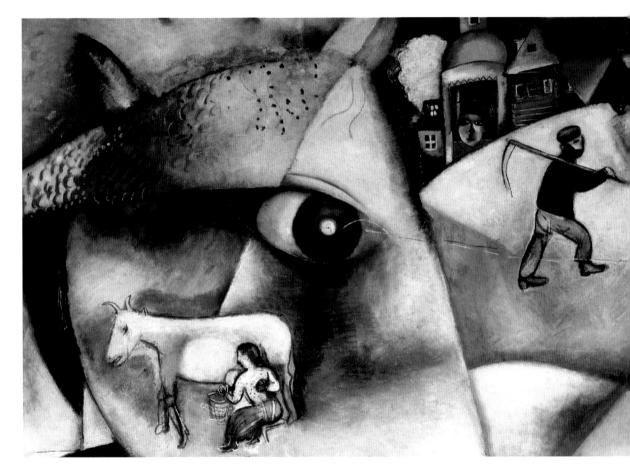

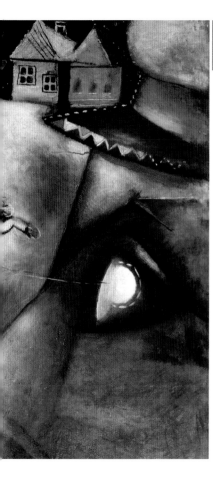

SYMBOLISM

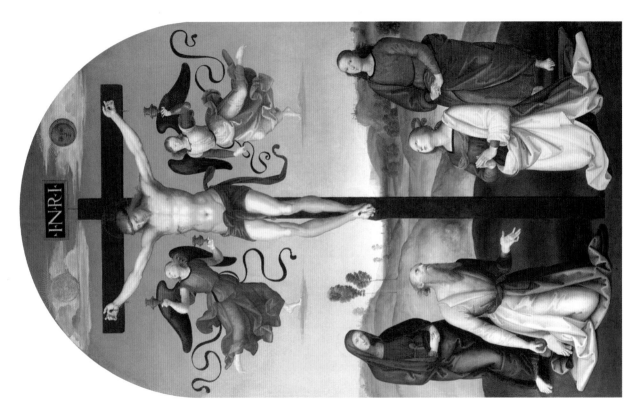

The Mond Crucifixion 1502–03

Raphael

One of the most important elements of *The Mond Crucifixion* is the artist's adherence to the Renaissance concept that the Golden Section, also known as the "Divine Proportion," was designed by God. An example of this theory is the geometry that has been discovered in nature, such as in plants, shells, and the human figure, as demonstrated by Leonardo da Vinci with *Vitruvian Man* (1492). It was, therefore, believed that the Golden Section should be incorporated into the hidden structure of sacred religious art to reflect great symbolic meaning.

As a whole, this painting is not an attempt to depict the actual scene as imagined by Raphael; it is symbolic of a religious scene in the story of Christ. A large compositional triangle can be seen, with Christ's chin the apex, and diagonals passing down both sides behind the back contours of the heads of the Virgin and Jerome, and ending with both sets of drapery on the ground. Join the two points with a horizontal line, and a triangle is formed. Circles can be deciphered, too. What is more difficult to see, but is fundamental to the design, is that pentagrams are present and constructed within the circles that dictate the design—for example, the diagonal movement of the angels.

In the fifteenth century, a certain feeble lamp of art arose in the Italian town of Urbino. This poor light, Raphael Sanzio by name, better known to a few miserably mistaken wretches in these later days as Raphael."

Charles Dickens
Old Lamps for New Ones

oil on poplar
111 ½ x 65 ¾ in (283 x 167 cm)
National Gallery,
London, UK

The Crucifixion (1515)
Gerard David
Gemaeldegalerie,
Berlin, Germany

Christ on the Cross (c.1632)
Diego Velázquez
Museo del Prado,
Madrid, Spain

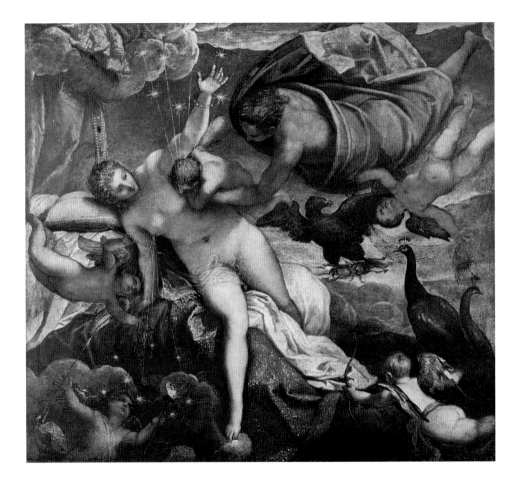

The Origin of the Milky Way *c.1575*
Jacopo Tintoretto

The story portrayed in *The Origin of the Milky Way* is from classical mythology and relates how Jupiter, father of the gods, tricked his wife Juno, a goddess, into nurturing one of his children by Alcmene, a mortal woman. Wanting the infant Hercules to gain immortality by drinking the milk of a goddess, Jupiter held the baby to Juno's breast while she was sleeping. Startled, she rose up and her milk spurted up into the sky, creating the Milky Way, and onto the earth below, creating lilies. This key moment is central to the structure of *The Origin of the Milky Way*: all the diagonals make up the dynamics of movement, giving a sense of flying and falling, a chaos engendered by Juno's rude awakening.

In *The Origin of the Milky Way*, Jacopo Tintoretto used symbols to signify how the ancient religion of the classical gods had evolved into the newer religion of Christianity. This was an interesting subject to choose at a time when the purpose and validity of Christianity was being debated by those who supported the new Renaissance belief of Humanism. In Renaissance art, lilies symbolized the Virgin Mary and peacocks symbolized the goddess Juno. Initially, this painting was larger, and the bottom section of the canvas, which was cut away, depicted lilies.

. . . the pictures of Tintoret [Tintoretto] in Venice were accurately the most precious articles of wealth in Europe, being the best existing productions of human industry."
John Ruskin *Munera Pulveris*

oil on canvas
58⅞ x 66⅛ in (149.5 x 168 cm)
National Gallery, London, UK

An Allegory With Venus and Cupid (c.1545)
Agnolo Bronzino
National Gallery, London, UK

Allegory of War (1628)
Sir Peter Paul Rubens
Liechtenstein Museum, Vienna, Austria

The Art of Painting (c.1666)
Johannes Vermeer
Kunsthistorisches Museum, Vienna, Austria

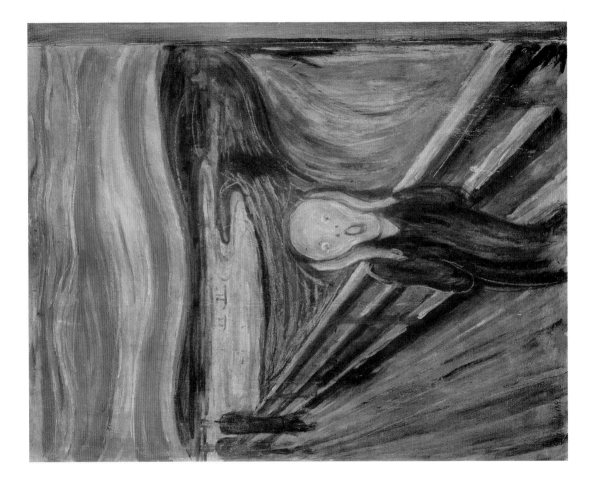

The Scream 1893
Edvard Munch

oil, tempera, and pastel
on cardboard
36 x 29 in (91 x 73.5 cm)
Nasjonalgalleriet, Oslo, Norway

Munch talked about "wanting to paint the memories of a sunset, red as blood," at least two years before the execution of this idea. The red he uses for the sky almost leaks blood. When he painted *The Scream*, the artist had endured much personal suffering: his mother had died when he was five and his older sister in her teens. His father had died just three years before *The Scream* was painted and another of his sisters was in an asylum. Perhaps it was at his sister's asylum that Munch "heard" the scream he felt the need to depict.

The Scream is one of the most recognized images of the twentieth century. Standing in front of it, viewers understand the horror, anguish, pain, and despair being conjured up by Norwegian artist Edvard Munch's frenzied brushstrokes. The haunting foreground figure, with its skull-like features—meant to make viewers think of death—clasps its hands to its head in distress, while the two background figures stroll along unscathed. This suggests that the apparent trauma exists only in the figure's mind and not in the outside world. The painting was part of a series—*The Frieze of Life*—produced over a period of at least thirty years and described by Munch as "a poem of life, love, and death."

> *The clouds were turning blood-red. I sensed a scream passing through nature."*
>
> Edvard Munch

Eve (1889)
Paul Gauguin
Art Institute of Chicago,
Illinois, USA

Violinist at the Window (1918)
Henri Matisse
Musée National d'Art Moderne,
Paris, France

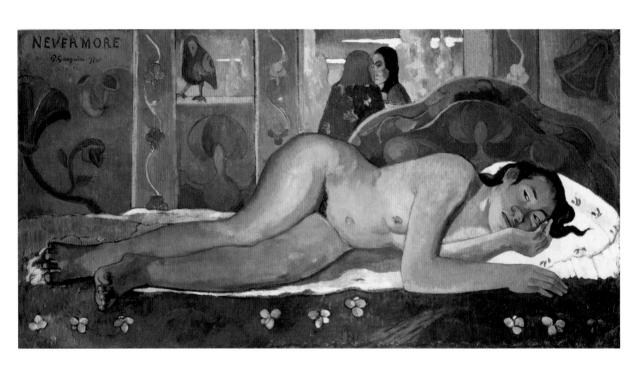

Nevermore O Tahiti 1897
Paul Gauguin

Whereas women in France were defined by their era—in terms of fashion, hairstyles, and surroundings—Gauguin saw the women in Polynesia as "timeless." He wrote, "With a simple nude I intended to suggest a certain savage luxuriousness of a bygone age"; he painted his models naked or in traditional clothing to emphasize this. *Nevermore O Tahiti* is an unsettling portrait of an adolescent, her uncertain face belying the apparent confidence of her nakedness. But why does she look so worried, and what are the two women discussing? This picture asks more questions than it is able to answer.

At the start of his career, Paul Gauguin was associated with the Impressionists, but he wanted to take his art further and make it less impressionistic, more poetic, and deeply symbolic. Inspired by the writing of Edgar Allan Poe, *Nevermore O Tahiti* was painted while Gauguin was living in the South Seas. He had long been influenced by non-Western art—including African and Asian styles—and living in Tahiti helped him to discover new concepts of color and symbolism as well as a greater understanding of sunlight.

> The title is Nevermore; *it is not Edgar Poe's raven keeping watch, but the Devil's bird. It's badly painted (I'm so nervous and I'm working in short bursts)—never mind, I think it's a good canvas."*

Paul Gauguin letter to Daniel de Monfreid

oil on canvas
19³/₄ x 45³/₄ in (50 x 116 cm)
The Courtauld Gallery, London, UK

The Pardon (1888)
Emile Bernard
Private collection

Les Demoiselles d'Avignon (1907)
Pablo Picasso
Museum of Modern Art,
New York, USA

Dance (1910)
Henri Matisse
State Hermitage Museum,
St. Petersburg, Russia

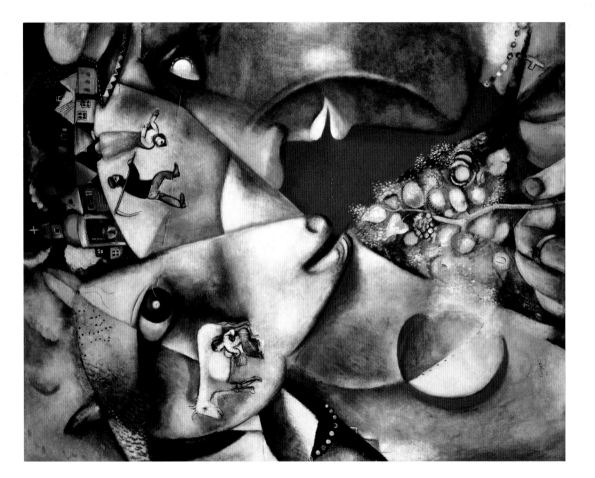

I and the Village 1911
Marc Chagall

I and the Village depicts a fantasy world where people and animals live side by side. The figures of man and cow are not only gazing at each other, their eyes are connected by an almost imperceptible line of dots. An upside-down element appears regularly in Chagall's work, and this is seen here in an upside-down woman and a row of upside-down houses. The use of soft geometric lines demonstrates the influence of cubism on the artist.

Inspired by homesickness and nostalgia, *I and the Village* was painted a year after Marc Chagall had left his home in Belarus and moved to France. He had studied art in St. Petersburg, all the time struggling through financial hardship, before moving to Paris. In reality, Chagall's home and village had been extremely poor, but with the benefit of distance he turned the remembered world of his childhood into a magical, enchanting place. There are many circles and sweeping movements in this painting, representing the circular pattern of life. The large circle—Earth—embraces the faces of both the man and the cow, as well as the flowering tree held in the man's hand and a crescent moon.

Lines, angles, triangles, squares carried me far away to enchanting horizons."

Marc Chagall

oil on canvas
75 ⁵⁄₈ x 59 ⁵⁄₈ in (192 x 151 cm)
Museum of Modern Art,
New York, USA

Improvisation III (1909)
Wassily Kandinsky
Musée National d'Art Moderne,
Paris, France

The Dream (1912)
Franz Marc
Museo Thyssen-Bornemisza,
Madrid, Spain

 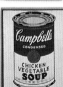 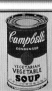

Campbell's Soup Cans 1962
Andy Warhol

The semimechanized process used to produce *Campbell's Soup Cans* was an essential part of this work. Able to be produced—and reproduced—at least partially by a machine, the very technique emphasized the artist's belief that consumerism had become so rife that art collectors no longer needed to buy great works of portraiture or magnificent landscapes. The consumer was king, and anything and everything could be art. *Campbell's Soup Cans* is not one painting; it comprises thirty-two identically sized and re-created individual works. The use of synthetic polymer paint (on canvas) emphasized the plasticity, the "dumbing down" of art. Yet Warhol's ironic statement piece rapidly acquired cult status.

In 1962, Campbell's Soup company offered thirty-two varieties of soup in a can. Andy Warhol reproduced each one using a silkscreen process. The almost identical, yet individual, soup cans were arranged in a manner suggestive of real cans stacked in a grocery store. This is symbolic not only of the kitsch consumerism of pop art, but also of the blandness of a nation's taste: where once food had been prepared from fresh ingredients, now the world could buy neatly packaged and containered pop art soup.

If you take a Campbell soup can and repeat it fifty times, you are not interested in the retinal image. What interests you is the concept that wants to put fifty Campbell soup cans on a canvas."

Marcel Duchamp

synthetic polymer paint on canvas
20 x 16 in (51 x 41 cm) each canvas
Museum of Modern Art,
New York, USA

First Toothpaste (1962)
Derek Boshier
Sheffield Galleries and Museum
Trust, Sheffield, UK

Jackpot Machine (1962)
Wayne Thiebaud
Smithsonian American Art
Museum, Washington, D.C., USA

Gears (1977)
James Rosenquist
Private collection

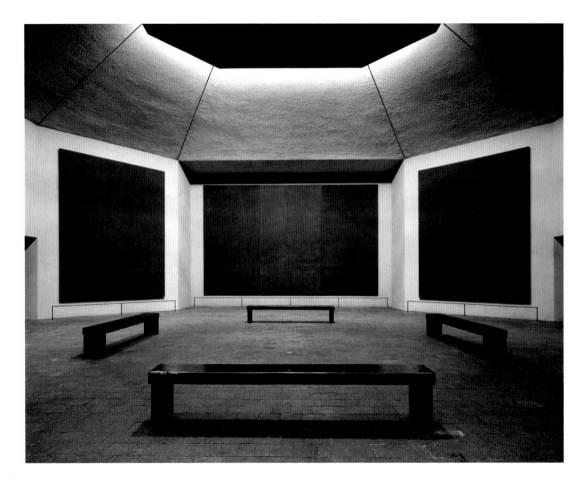

Rothko Chapel 1964–70
Mark Rothko

The Rothko Chapel is octagonal and displays fourteen large-scale paintings, lit by natural light. The center and side walls house three triptychs with a further five single works. The paintings are very dark in color, dominated by large expanses of blacks, mauves, and dark red earth colors. For all the symbolism and associations that black can hold, the concept for the chapel was of a spiritual and contemplative world, where visitors can find peace and solace. Rothko himself, with his own inner turmoils, sadly never saw the opening of the chapel, which he also helped to design. He committed suicide in 1970, the year before it was finished.

Mark Rothko was one of the avant-garde artists of the New York School, and in 1964 he was commissioned by John and Dominique de Menil to produce a cycle of works to fill and occupy a chapel. Rothko was famed for his "multiforms"—as they were described by critics—which were thin layers of brightly colored oil paint applied quickly, sometimes onto an unprimed canvas, to make bands of horizontal color fields. The paintings were not supposed to represent the outer visual world but symbolized "basic human emotions." For the chapel Rothko spurned the usual concept of intimacy, such as miniature devotional icons, and instead created grand, huge paintings. He wanted them to surround his viewers, to create a close bond.

And if you, as you say, are moved only by the color relationships, then you miss the point."
Mark Rothko

oil on canvas
various dimensions
Rothko Chapel, Houston,
Texas, USA

Vir Heroicus Sublimis (1950–51)
Barnett Newman
Museum of Modern Art,
New York, USA

1952—A (1952)
Clyfford Still
San Francisco Museum
of Modern Art, California, USA

Pompeii (1959)
Hans Hofmann
Tate Collection,
London, UK

Be I (Second Version) 1970
Barnett Newman

The collective ideas of Newman suggest that, behind the symbolism of the title *Be I (Second Version)*, the picture represents the sign for the sublime, religious, physical, and metaphysical sensation of "Be'ing." Although Newman believed that he was "free from the weight of European culture," there is still a relationship with religion within this work, and a number of his works have biblical titles, such as the series *Stations of the Cross* (1958–66; *First Station*, left). The "zips" have been referred to as symbols for God and may symbolize God creating the world from the nothingness of the void.

Barnett Newman is one of the New York school of abstract expressionist artists and a color field painter. Initially, he had few supporters and was often obliged to defend his art and philosophy to his critics. *Be I (Second Version)* is a very large painting, and the canvas is bisected by a vertical line, or "zip" as it is known, something that became characteristic of the artist's work from 1948 onward. The "zip" is not a division, for the painting is to be viewed as a whole. Newman himself suggested the meaning of the "zip" as a metaphor for "streaks of light."

What is the raison d'etre, what is the explanation of the seemingly insane drive of a man to be a painter and poet if it is not an act of defiance against man's fall and an assertion that he return to the Adam of the Garden of Eden?"

Barnett Newman

acrylic on canvas
111 1/2 x 83 7/8 in (283 x 213 cm)
Detroit Institute of Arts,
Michigan, USA

Untitled (1955)
Mark Rothko
National Gallery of Art,
Washington, D.C., USA

Abstract Painting Diptych (1959)
Ad Reinhardt
Private collection

ARTISTS

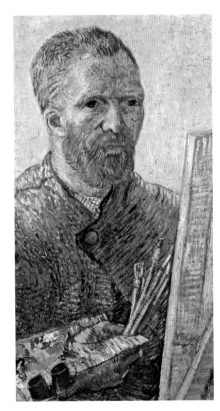

Josef Albers

b. 1888 Bottrop, Westphalia, Germany
d. 1976 Orange, New Haven,
Connecticut, USA

Josef Albers studied art in Berlin, Essen, and Munich, and in 1923 he began teaching furniture design and typography at the Bauhaus School. When the Bauhaus closed in 1933, Albers immigrated to the United States. He spent the next sixteen years teaching at the Black Mountain College in North Carolina, beginning the series of paintings he would work on until his death, *Homage to the Square*, in 1949. From 1950 to 1959, Albers led the department of design at Yale University. He published his research into the psychological effects of color and space in his book, *Interaction of Color*, in 1963.

⧫ *Study for Homage to the Square* **p.173**

Francis Bacon

b. 1909 Dublin, Ireland
d. 1992 Madrid, Spain

Born in Ireland to English parents, Francis Bacon and his family moved to London when World War I broke out in 1914. Bacon went to live in Berlin in 1927, then moved to Paris and began to paint in watercolor. He returned to London a year later, working as an interior and furniture designer. Bacon started to paint in oils in a style that was influenced by Pablo Picasso and the surrealist movement. His first major solo exhibition in 1951 included the first of a series of paintings based on Diego Velázquez's *Portrait of Pope Innocent X* (1650). In 1962, the Tate Gallery in London held a retrospective of his work.

⧫ *Study After Velázquez's Portrait of Pope Innocent X* **p.31**

Gianlorenzo Bernini

b. 1598 Naples, Italy
d. 1680 Rome, Italy

Gianlorenzo Bernini trained under his father, the sculptor Pietro Bernini, who introduced him to the powerful Roman families, the Borghese and Barberini. In 1623, Maffeo Barberini became Pope Urban VIII and appointed Bernini as chief papal artist in charge of architectural and artistic projects. When Urban VIII died in 1644, Bernini fell from papal favor. He continued to win commissions, including *The Ecstasy of St. Theresa* (1647–52) for the Church of Santa Maria della Vittoria. With the accession of Pope Alexander VII in 1655, Bernini's position with the papacy was restored, and he designed the colonnades at St. Peter's piazza.

� *The Ecstasy of St. Teresa* **p.95**

Sandro Botticelli

b. c.1444 Florence, Italy
d. 1510 Florence, Italy

Born Alessandro di Mariano di Vanni Filipepi, the son of a tanner, the artist later became known as "Botticelli," meaning "little barrel." He was apprenticed as a goldsmith but was sent to study under Fra' Filippo Lippi because he preferred painting. Botticelli opened a workshop in 1470 and went on to develop his graceful naturalistic style, receiving commissions from the powerful Medici family and the Church. In 1481 he formed part of a team commissioned to paint frescoes in Rome's Sistine Chapel. Botticelli's style in later years became increasingly bare as he abandoned decorative motifs in his work.

▸ *The Birth of Venus* **p.63**

Georges Braque

b. 1882 Argenteuil-sur-Seine, Val-d'Oise, France
d. 1963 Paris, France

Georges Braque grew up in Le Havre and trained to become a painter and decorator, while studying fine art in the evenings. His early influences were impressionism, fauvism, and the work of Paul Cézanne, but the biggest influence on his work was Pablo Picasso, whom he met in 1907. The artists worked together in Paris and also in Céret in the French Pyrenees, forging the tenets of cubism. In 1914, Braque enlisted in the French army and fought in World War I until 1917, when he was wounded. He moved to Normandy where, working alone, his style remained cubist but with a meditative character.

▸ *Studio V* **p.139**

Paul Cézanne

b. 1839 Aix-en-Provence, France
d. 1906 Aix-en-Provence, France

Paul Cézanne began his career studying law, but in 1861 he switched to art and attended the Académie Suisse in Paris, where he met Camille Pissarro. However, consumed with self-doubt, Cézanne returned to his hometown of Aix-en-Provence. In 1862 he went back to Paris, where he exhibited at the Salon des Refusés and mixed with impressionist artists. In 1872, Cézanne began working at Pontoise with Pissarro, who helped him to develop his mature style. Cézanne participated at two of the impressionist exhibitions but preferred to work alone. After a solo show in 1895 he began to achieve recognition.

>> *Still Life With Apples* **p.133**

Marc Chagall

b. 1887 Vitebsk, Belarus
d. 1985 Saint-Paul de Vence,
 Alpes-Maritimes, France

Born Moishe Shagal, the eldest of nine children, Marc Chagall spent most of his adult life living in France, although his work largely reflects Russian-Jewish folklore and village life. Chagall lived in Paris from 1910 to 1914, and his work from this time shows distinct cubist influences. He had his first solo exhibition in Berlin in 1914, but as World War I broke out he returned to Vitebsk. He was director of the art school in Vitebsk from 1917 to 1920 but left after disagreements, eventually settling in France. He fled with his family to the United States during World War II and returned to France in 1948.

>> *I and the Village* **p.187**

Jean-Siméon Chardin

b. 1699 Paris, France
d. 1779 Paris, France

Regarded as one of the foremost exponents of still life painting, Parisian Jean-Siméon Chardin never left the city of his birth, except to visit Versailles or Fontainebleau. In 1728 he was accepted by the Académie Royale (Royal Academy), which was the beginning of a long relationship with the institution, and he went on to serve as its treasurer from 1755 to 1774. From 1737 he exhibited regularly at the Salon, and in 1752 he won royal favor when King Louis XV granted him an annual allowance and lodgings in the Louvre. His still lifes and later genre paintings are known for their remarkable realism.

>> *Still Life With Jar of Olives* **p.43**

John Constable

b. 1776 East Bergholt, Suffolk, England
d. 1837 London, England

The son of a prosperous corn merchant, John Constable began his career working in the family business, but in 1799 he entered the Royal Academy Schools in London and studied there until 1802. He sold only twenty landscapes in England in his lifetime, and his landscapes based on oil sketches made from nature were seen as ordinary in comparison to the grand manner landscapes fashionable at the time. In 1824, three of his works were exhibited at the Paris Salon, and his *The Hay Wain* (1821) won a Gold Medal. Eight years later the Royal Academy finally awarded him full membership.

» *Study of the Trunk of an Elm Tree* **p.119**

Gustave Courbet

b. 1819 Ornans, Franche-Comté, France
d. 1877 La Tour-de-Peilz, Vevey, Vaud, Switzerland

Jean Désiré Gustave Courbet studied art in Besançon and then Paris, where he moved in 1839. However, Courbet never felt at home in the capital and his rural background drew him back repeatedly. He developed an original style that addressed rural life with honest realism. A major milestone came at the 1851 Salon, with two paintings that gave everyday life the monumentality that was the traditional preserve of grand history painting. By the early 1870s he was president of the Fédération des Artistes (Federation of Artists), dedicated to expanding art and freedom from censorship, and he was active in the Paris Commune.

» *The Sleepers* **p.99**

Edgar Degas

b. 1834 Paris, France
d. 1917 Paris, France

Hilaire-Germain-Edgar de Gas studied law but was determined to become an artist. He enrolled in the Ecole des Beaux-Arts in Paris, after which he spent three years traveling and studying in Italy. Degas exhibited at the Paris Salon for the first time in 1865 and was one of the Société Anonyme des Artistes who exhibited together from 1874 onward. Their first show was later labeled pejoratively the "Exhibition of the Impressionists" because the artists' style of painting lacked detail. In 1886, Degas's works were shown in New York, and in 1905, Degas and many of the impressionists exhibited paintings in London.

» *After the Bath, Woman Drying Herself* **p.149**

André Derain

b. 1880 Chatou, Ile-de-France, France
d. 1954 Garches, Hauts-de-Seine,
 Ile-de-France, France

André Derain was one of the founders of fauvism, bringing his vision to maturity with Henri Matisse in 1905. Best known for his fauve landscapes, Derain constantly reinvented his art practice. Initially influenced by African art and by cubism, he later delighted in archeological finds and High Renaissance painting, and from 1921 onward his figurative works marked a return to tradition. He enjoyed a period of success with a retrospective at the Kunsthalle in Bern in 1935. World War II marked the beginning of a string of disastrous events for Derain, and reported associations with the Third Reich contributed to his decline.

⯈ *Boats in the Harbor at Collioure* **p.25**

Theo van Doesburg

b. 1883 Utrecht, Netherlands
d. 1931 Davos, Switzerland

Theo van Doesburg was born Christian Emil Marie Küpper. He had his first exhibition in 1908 at The Hague. From 1914 to 1916 he served in the Dutch army, and in 1917 he cofounded the De Stijl (The Style) group. From 1922 onward he taught at the Weimar Bauhaus and became involved with the Dadaists. He had a solo show at Weimar's Landesmuseum in 1924 and published *Principles of Neo-Plastic Art* the same year. His manifesto promoting the diagonal, *Elementarism*, was released in 1926. In 1929 he published the first issue of *Art Concret* (Concrete Art) and began to focus on architecture.

⯈ *Counter-Composition of Dissonances, XVI* **p.137**

Marcel Duchamp

b. 1887 Blainville-Crevon, Normandy, France
d. 1968 Neuilly-sur-Seine, France

Henri-Robert-Marcel Duchamp changed art forever when he created his "readymades" using subjects as diverse as a urinal and a bicycle wheel. He studied at Paris's Académie Julian, and his early works were influenced by post-impressionism and fauvism. His mechanistic *Nude Descending a Staircase, No. 2* (1912) gained attention at the Salon des Indépendants, but Duchamp was asked to remove it. The painting also caused controversy at New York's Armory Show a year later. Duchamp lived in New York from 1915 to 1923, where he helped form the city's Dada movement.

⯈ *Nude Descending a Staircase, No. 2* **p.151**

Albrecht Dürer

b. 1471 Nuremberg, Germany
d. 1528 Nuremberg, Germany

Draftsman, printmaker, painter, and author Albrecht Dürer was born the son of a goldsmith, and he started his career learning the family trade. His artistic talent was evident, so he trained as a painter and printmaker under Michel Wolgemut. In 1492 he began working for publishers in Switzerland and France. He returned home in 1494 before going to Italy, where he was impressed by the work of Early Renaissance painter Andrea Mantegna. On his return, Dürer set up a workshop to concentrate on printmaking. In 1512 he was granted an annual allowance by the Holy Roman Emperor, Maximilian I.

» *Self-Portrait at Thirteen* **p.37**

Euthymides

a. 515–500 BCE Athens, Greece

Although only eight vessels signed by the ancient Athenian potter and painter Euthymides have survived, they bear testament to his mastery of red-figure painting. Euthymides was a pioneer of the technique, which shows red figures and patterns unglazed against a glossy black background. Figures were drawn in outline with a brush, and the background was painted black. This meant that it was easier for artists to depict the human figure with a degree of realism. Euthymides excelled in the new technique, and he was one of the first artists known to use foreshortening to create dynamic figures.

» *The Warrior's Leave-taking* **p.111**

Piero della Francesca

b. c.1416 Sansepolcro, Tuscany, Italy
d. 1492 Sansepolcro, Tuscany, Italy

Piero della Francesca gained an apprenticeship in the workshop of painter Domenico Veneziano. From 1439 to 1442 he assisted Veneziano on a series of frescoes for the hospital of Santa Maria Nuova. He led a peripatetic life, working in Rome, Ferrara, Rimini, and Arezzo painting religious works known for their innovative use of linear perspective and light and shadow to create three-dimensional space. His patrons included the Dukes of Urbino, the Malatesta family in Rimini, and Pope Nicholas V in Rome. In later years he wrote theoretical works on geometry, mathematics, and perspective.

» *The Flagellation of Christ* **p.127**

Thomas Gainsborough

b. 1727 Sudbury, Suffolk, England
d. 1788 London, England

Thomas Gainsborough is thought
to have trained in London under
the engraver Gravelot and painter
and illustrator Francis Hayman.
Gainsborough's landscape paintings
were admired but failed to sell
well, and in 1748 he returned to his
hometown of Sudbury to address
the market for portraiture, where he
painted his renowned *Mr. and Mrs.
Andrews* (c.1750). In search of clients,
he moved first to Ipswich and then to
fashionable Bath. He became one of
the founding members of the Royal
Academy of Arts in 1768 and settled
in London six years later, although he
continued to paint landscapes.

» *Mr. and Mrs. Andrews* **p.67**

Paul Gauguin

b. 1848 Paris, France
d. 1903 Atuona, Hiva Oa, Marquesas
 Islands, French Polynesia

In 1872, Eugène Henri Paul Gauguin
was a successful stockbroker in
Paris and a year later he married.
He went on to have five children
but then abandoned his family to
pursue his artistic goals. By 1885,
Gauguin had become a painter and
a dominant figure in Parisian artistic
circles. Disillusioned by his lack of
popular success, Gauguin moved to
rural Brittany for a more carefree life
and by 1888 he had adopted a more
expressive, less impressionist style.
In 1895 he traveled to Tahiti in search
of ancient and indigenous inspiration
and spent the last years of his life
exploring Oceania.

» *Nevermore O Tahiti* **p.185**

Théodore Géricault

b. 1791 Rouen, France
d. 1824 Paris, France

Jean-Louis-André-Théodore Géricault's
family relocated to Paris from Rouen.
Early mentors were Carle Vernet, who
fed his talent for sporting art, and the
classicist Pierre-Narcisse Guérin.
Géricault also spent years copying the
Louvre's Old Masters and had a two-
year stay in Italy starting in 1816. He
won a Paris Salon Gold Medal in 1812,
and another in 1819 for *The Raft of the
Medusa* (1818–19), which caused a
scandal because it depicts a real-life
shipwreck. In 1820, Géricault went to
England, where his masterpiece proved
popular. He returned to France two
years later and produced portraits of
mental patients with a new humanity.

» *The Raft of the Medusa* **p.83**

Alberto Giacometti

b. 1901 Borgonovo, Stampa, Switzerland
d. 1966 Chur, Graubünden, Switzerland

Alberto Giacometti created his first sculpture at the age of fourteen. His father, Giovanni, was a well-known post-impressionist painter and his first teacher. He studied art in Geneva and then toured Italy, sketching classical architecture. In 1922 he moved to Paris, where he studied under sculptor Emile-Antoine Bourdelle for three years and experimented with cubism and constructivism. After meeting André Breton in 1930, Giacometti joined the surrealists. During World War II he moved back to Geneva, returning to Paris after the war to develop his original style of elongated, figurative bronzes with an irregular finish.

▶ *Annette in the Studio* **p.175**

Giotto di Bondone

b. c.1266 Vespignano, Tuscany, Italy
d. 1337 Florence, Italy

Giotto di Bondone studied painting in Florence under Cimabue. He is known to have worked in Rome between 1297 and the turn of the century. In 1304, Giotto began the earliest work solely attributed to him, a masterful fresco cycle for the Capella degli Scrovegni at Padua, depicting the life of the Virgin, the life of Christ, and the Passion. From 1314 to 1327, Giotto spent most of his time in Florence and Rome before he was summoned to work as court painter to King Robert of Anjou in Naples. In 1334 he was appointed chief architect for Florence Cathedral, and he spent his last years painting in Milan and Florence.

▶ *Lamentation of the Death of Christ* **p.17**
▶ *The Road to Calvary* **p.75**

Vincent van Gogh

b. 1853 Zundert, North Brabant, Netherlands
d. 1890 Auvers-sur-Oise, France

Vincent Willem van Gogh worked in an art dealership and trained as a minister before he decided to become a painter in 1880. He moved to Paris in 1886 and was influenced by the impressionists and neoimpressionists. In 1888 he moved to Arles in the south of France, planning to create an artists' colony. There he produced more than 200 paintings in fifteen months. He severed his left earlobe following a quarrel, and in 1889 he entered an asylum as a voluntary patient for a year, although he continued to paint. The next year he moved to Auvers-sur-Oise near Paris, but after only a few months he shot himself in the chest.

▶ *Wheat Field With Crows* **p.23**
▶ *The Man With the Puffy Face* **p.49**

Francisco de Goya

b. 1746 Fuendetodos, Aragon, Spain
d. 1828 Bordeaux, France

In his early career, Francisco José de Goya y Lucientes received a stream of commissions from the aristocracy. He was appointed painter to King Charles III, and in 1789 he became court painter to King Charles IV. Goya's work became more experimental after he suffered an illness that left him deaf in c.1792, and his painting style became much darker after France invaded Spain in 1808. He did not receive any royal commissions after the Bourbon monarchy was reinstated in 1813. Between 1820 and 1823, Goya completed a series of somber wall paintings in his house near Madrid before retiring to France.

⊠ *The Third of May, 1808* **p.81**

Mathis Grünewald

b. c.1475/80 Würzburg, Germany
d. 1528 Halle, Germany

Although he was a talented painter, draftsman, hydraulic engineer, and architect, after his death the German artist Mathis Grünewald was forgotten, and his importance rests with his masterpiece, the Isenheim Altarpiece (1512–15). His real name remains uncertain, and "Grünewald" is a nickname given to him by his seventeenth-century biographer, Joachim von Sandrart. Little is known of Grünewald's career, although it is clear that by 1510 he was working as court painter for the archbishop of Mainz. Grünewald's artistic skill lay in uniting Italian idealization with Northern European realism.

⊠ *Crucifixion, from the Isenheim Altarpiece* **p.19**

Edward Hopper

b. 1882 Nyack, New York, USA
d. 1967 New York City, New York, USA

Edward Hopper studied at the New York Institute of Art and Design under William Merritt Chase, who encouraged his students to create realistic paintings of urban life. Hopper made three trips to Paris between 1906 and 1910, but he was indifferent to the avant-garde movements he encountered. He worked as a commercial artist and sold his first painting at New York's Armory Show in 1913. After his second solo show in New York in 1924 was a sellout, he turned to painting full time. He gained recognition as an American realist, and in 1933 the Museum of Modern Art held a retrospective of his work.

⊠ *Nighthawks* **p.121**

Jean-Auguste-Dominique Ingres

b. 1780 Tarn-et-Garonne, France
d. 1867 Paris, France

Jean-Auguste-Dominique Ingres studied under neoclassical painter Jacques-Louis David in Paris. In 1801 he won the Prix de Rome and was soon receiving portrait commissions from Napoleon Bonaparte. Ingres lived in Italy from 1806, first in Rome and then Florence, where he produced his first female nudes, including *La Grande Odalisque* (1814). Success in France came in 1824 at the Paris Salon. Ingres returned to Paris and went on to work as official painter to the newly restored monarchy. He received the cross of the Légion d'honneur in 1825 and a year later became a professor at the Ecole des Beaux-Arts.

⟫ *La Grand Odalisque* **p.45**
⟫ *Madame de Senonnes* **p.165**

Wassily Kandinsky

b. 1866 Moscow, Russia
d. 1944 Neuilly-sur-Seine, France

Wassily Kandinsky studied law and economics at the University of Moscow until he moved to Germany in 1896, where he attended the Akademie der Bildenden Künste (Academy of Fine Arts). He painted landscapes and themes inspired by Russian folk art before concentrating on abstract works. In 1910 he wrote *Concerning the Spiritual in Art*, outlining his theories on the spiritual value of art and the emotional potential of color. A year later he cofounded the Der Blaue Reiter (The Blue Rider) group. In 1922, Kandinsky was appointed a professor at the Bauhaus School. After the school closed in 1933, he moved to Paris.

⟫ *Composition No. 6* **p.27**

Hokusai Katsushika

b. 1760 Tokyo, Japan
d. 1849 Tokyo, Japan

Born Tokitaro, Hokusai Katsushika was apprenticed to a woodblock carver when he was fourteen years old and then entered the studio of Katsukawa Shunsho, a master of the ukiyo-e woodblock print. In 1795, Hokusai affiliated himself with the Tawaraya School, working on illustrations, calendars, and a series of bijinga pictures of beautiful women. He set up independently in 1798 and developed his own style, bringing together influences from the West, China, and Japan. By 1820, Hokusai had gained considerable success, and he produced some of his most widely acclaimed works in his last years.

⟫ *The Dream of the Fisherman's Wife* **p.97**

Utamaro Kitagawa

b. c.1753
d. 1806 Tokyo, Japan

Little is known of Kitagawa's early life due to a lack of documentation. He is believed to have been a pupil of Toriyama Sekien since childhood and the two remained friends until Sekien's death in 1788. Kitagawa's earliest known professional work was a cover for a book of plays published in 1775. After that he produced prints on numerous subjects, although he is best known for his portraits of individual women. In 1804 he was prosecuted for publishing prints illustrating scenes from a banned novel. The prints led to Kitagawa's brief imprisonment and ended his career. He died two years later.

⌦ *Artisans Making a Woodcut* **p.145**

Gustav Klimt

b. 1862 Baumgarten, Penzing,
 Vienna, Austria
d. 1918 Vienna, Austria

Gustav Klimt studied at Vienna's Kunstgewerbeschule (School of Arts and Crafts). In 1882 he opened a studio with his brother Ernst, and for the next fifteen years they produced murals for public buildings. He became increasingly experimental, and in 1894 the ornamentation and eroticism of his murals for Vienna University caused a scandal. In a stand against the oppressive classicist establishment, he and some other Viennese artists founded the Sezession (Secession) in 1897 to promote the work of avant-garde young artists. He was elected president, and they went on to develop the Viennese version of art nouveau.

⌦ *Danaë* **p.101**

L. S. Lowry

b. 1887 Stretford, Lancashire, England
d. 1976 Glossop, Derbyshire, England

Laurence Stephen Lowry lived most of his life in or near Manchester, mainly in Salford, and studied art intermittently from 1905 to 1925, most notably at Manchester School of Art. He worked as a rent collector and clerk for a property company until he retired in 1952, painting in the evenings. Lowry painted urban subjects featuring industrial buildings and groups of distinctive, sticklike figures. He had his first solo show at the Reid and Lefevre Gallery in London in 1939, which helped to establish his reputation, and after his death in 1976, London's Royal Academy held a retrospective of his work.

⌦ *Good Friday, Daisy Nook* **p.155**

Andrea Mantegna

b. c.1431 Isola di Carturo, near Padua, Italy
d. 1506 Mantua, Italy

At eleven years old, Andrea Mantegna was apprenticed to Paduan painter Francesco Squarcione, and six years later he left Squarcione to become an independent painter. His first large-scale scheme was the decoration of the Ovetari Chapel in Padua. In 1453, Mantegna was commissioned to paint the St. Luke altarpiece for the Benedictines of San Giustina, Padua. In 1460 he moved to Mantua to become court painter to Ludovico Gonzaga, where he produced some of his most famous works. In 1448, Mantegna went to Rome to paint the Belvedere Chapel in the Vatican, after which he returned to Mantua.

⊠ *The Lamentation Over the Dead Christ* **p.161**

Masaccio

b. 1401 San Giovanni Valdarno, Arezzo,
 Tuscany, Italy
d. c.1428 Rome, Italy

Tommaso di Ser Giovanni di Mone Cassai was given the nickname "Masaccio" as a child, and the name means "clumsy Tom." In 1422 he enrolled in the painters' guild, the Arte dei Medici e Speziali, in Florence, and starting in 1424 he worked on the decoration of the Brancacci Chapel in the Church of Santa Maria del Carmine in Florence; the following year he painted an altarpiece in Santa Maria Maggiore in Rome. He is well known for his innovative methods to depict linear perspective, which is shown to startling effect in his *The Holy Trinity* (c.1427) in Santa Maria Novella in Florence.

⊠ *The Holy Trinity* **p.115**
⊠ *The Virgin and Child* **p.125**

Henri Matisse

b. 1869 Le Cateau-Cambrésis, Nord-
 Pas-de-Calais, France
d. 1954 Nice, Alpes-Maritimes, France

Henri-Emile-Benoît Matisse began taking drawing classes while working as a legal clerk, and he moved to Paris in 1891 to study painting. He went on to become one of the founding fathers of fauvism with André Derain in 1905. Matisse remained in Paris during most of World War I, but in 1917 he relocated to Nice, where his use of color grew more intense, most apparent in his paintings of odalisques and interiors of rooms. In 1925 he was awarded the highest French honor, the Légion d'honneur, for his services to art. After surgery in 1941, Matisse was unable to paint and he began making paper cutouts.

⊠ *Bathers With a Turtle* **p.85**
⊠ *Large Reclining Nude* **p.169**

K
L
M

Michelangelo

b. 1475 Caprese, Tuscany, Italy
d. 1564 Rome, Italy

Michelangelo di Lodovico Buonarroti Simoni began an apprenticeship in the Florence workshop of painter Domenico Ghirlandaio in 1488, but after a year he transferred to the academy of sculptor Bertoldo di Giovanni, sponsored by Lorenzo de' Medici. After Lorenzo's death in 1492, Michelangelo decamped to Venice then Bologna before arriving in Rome in 1496, where he secured a reputation as a sculptor and painter. In 1508 he started work on his fresco cycle in the Sistine Chapel. The ensuing decades saw him achieve success in many fields, and in 1546 he was appointed architect to St. Peter's.

Claude Monet

b. 1840 Paris, France
d. 1926 Giverny, Eure,
　　　　Haute-Normandie, France

Oscar Claude Monet grew up in Le Havre in Normandy, where he met landscape painter Eugène Boudin, who introduced him to painting en plein air. In 1859, Monet left for Paris to study at the Académie Suisse. He cofounded the Société Anonyme des Artistes, and the group held its first exhibition in 1874. It included *Impression, Sunrise* (1872), which drew scorn from the critics for its unfinished appearance. Monet's fascination with light reached new heights in his series of paintings depicting haystacks, trees, and Rouen Cathedral at different times of day. In later life he painted the water-lily ponds he created at Giverny.

Henry Moore

b. 1898 Castleford, West Yorkshire, England
d. 1986 Much Hadham,
　　　　Hertfordshire, England

Born the son of a coal miner, Henry Moore excelled in imitating classical models at London's Royal College of Art in the 1920s but rejected conventional sculptural practice and academic classical principles for direct carving and the influence of pre-Colombian, Oceanic, and African art. He found a sculptural ideal based on "truth to materials" that explored the artistic possibilities of abstract form and the inherent potential of his materials. During the 1930s, Moore was a member of the British avant-garde. After World War II he became well known for his monumental bronze sculptures.

Edvard Munch

b. 1863 Adalsbruk, Løten, Hedmark,
 Norway
d. 1944 Ekely, Skøyen, Oslo, Norway

Edvard Munch studied art at Oslo's Royal School of Art and Design under naturalistic painter Christian Krohg. Through trips to France, Germany, and Italy, he became influenced by impressionism and symbolism. His parents, a brother, and a sister died when he was young, and mental illness affected both him and another sister. Although his life was troubled, he planned his angst-ridden paintings carefully, and *The Scream* (1893) is regarded as an icon of existential anguish. After a nervous breakdown in 1908, Munch's work became more optimistic, and he increasingly turned to painting scenes of nature.

» *The Scream* **p.183**

Barnett Newman

b. 1905 New York, USA
d. 1970 New York, USA

Born to Russian parents who had emigrated from Poland, Barnett Newman was educated at the Art Students League in New York. The canvases he executed prior to 1950 can be seen as rehearsals for what would become an established formal vocabulary. From this point, Newman developed his aesthetic, gradually refining the relationship between figure and ground, which often entailed punctuating vast expanses of unvariegated color with a series of what he called "zips." Newman went on to become known for paintings and sculptures that center on the predicament of a figure in space.

» *Be I (Second Version)* **p.193**

Pablo Picasso

b. 1881 Málaga, Spain
d. 1973 Mougins, France

Pablo Picasso dominated twentieth-century art. Shifting from one style to another and between media, his output was prolific, always original, and often provocative. He studied at La Coruña Arts School when he was eleven years old and enrolled at the Academia de San Fernando in Madrid when he was twenty. In 1904 he settled in Paris. His Primitive Period was inspired by pre-Roman Iberian sculpture, and *Les Demoiselles d'Avignon* (1907) shows the influence of African and Oceanic art and a shift toward cubism. During the Spanish Civil War his work became anti-Fascist, as seen in *Guernica* (1937).

» *Guernica* **p.29**
» *Les Demoiselles d'Avignon* **p.167**

Jackson Pollock

b. 1912 Cody, Wyoming, USA
d. 1956 East Hampton, New York, USA

Paul Jackson Pollock enrolled at Los Angeles Manual Arts High School in 1928 and then attended New York's Art Students League. He went on to work for the Federal Art Project. His work consisted of landscapes and figurative scenes based on Wild West themes. Pollock battled with alcoholism and depression, and after spending time in a psychiatric hospital in 1937, his work shifted toward abstraction. His wall-size piece, *Mural* (1943), was his first step toward developing his own style, a linear invention of Expressionism. From 1947 to 1951, Pollock produced a series of drip paintings that rocked the art world.

Nicolas Poussin

b. 1594 Les Andelys, Normandy, France
d. 1665 Rome, Italy

Nicolas Poussin's first encounter with painting was through the work of minor painters in Northern France. He went to Paris in 1612 but struggled to make a living and moved to Rome in 1624, where Cardinal Francesco Barberini became his patron and commissioned the *Martyrdom of St. Erasmus* (1628–29). In 1630, Poussin abandoned public commissions and began to paint historical narratives drawn from antique and biblical texts for private collectors. He returned to Paris in 1640 and was appointed first painter to King Louis XIII, but returned to Rome two years later.

Raphael

b. 1483 Urbino, Marche, Italy
d. 1520 Rome, Italy

Raffaello Sanzio was the son of Giovanni Santi, a court painter to the Duke of Urbino, Federico da Montefeltro. Raphael received an apprenticeship at Perugia, Umbria, where he spent time in the studio of Pietro Perugino, whose graceful style influenced *The Mond Crucifixion* (1502–03) altarpiece. Raphael moved to Florence in 1504, where he produced some of his best known Madonna paintings. In 1508, Raphael was summoned to Rome by Pope Julius II, where he painted frescoes for the Vatican. Other Roman projects include portraits, a series of Vatican tapestries, and architectural design for St. Peter's.

Rembrandt van Rijn

b. 1606 Leiden, Netherlands
d. 1669 Amsterdam, Netherlands

Rembrandt van Rijn studied under Jacob van Swanenburgh and Pieter Lastman. He opened a studio in his hometown, Leiden, producing many of his numerous self-portraits. His work caught the eye of Constantijn Huygens, secretary to the Prince of Orange, resulting in commissions from The Hague. In 1631, Rembrandt moved to Amsterdam and cornered the market for portraits of wealthy patricians. He became a member of the Guild of St. Luke in 1634; his workshop prospered and his fame grew with a series of biblical and historical masterpieces. In later years his commissions dried up, and he was declared bankrupt in 1656.

▷ *Self-Portrait at the Age of 63* **p.117**

Sir Joshua Reynolds

b. 1723 Plympton, Devon, England
d. 1792 London, England

In 1740, Sir Joshua Reynolds was apprenticed to portrait painter Thomas Hudson. He met the aristocratic naval officer Commodore Augustus Keppel in 1749 and journeyed with him to Rome, where he remained for two years, painting portraits and studying the Old Masters. Reynolds settled in London in 1753, where he entertained the fashionable visitors to his studio with paintings in the grand style. His gregarious nature and aristocratic support resulted in a prolific body of work. He was elected president of the Royal Academy when it was founded in 1768 and was knighted by King George III a year later.

▷ *Lady Worsley* **p.163**

Bridget Riley

b. 1931 Norwood, London, England

Bridget Riley studied art at London's Goldsmiths College and the Royal College of Art. Initially, Riley painted figure subjects in a semi-impressionist manner, before changing to pointillism and producing landscapes. In 1960 she began to paint her black-and-white works that explore optical phenomena, and she had her first solo show in 1962 at London's Gallery One. In 1965, Riley exhibited at the "The Responsive Eye" show at New York's Museum of Modern Art, and in 1968 she represented Great Britain in the Venice Biennale. More recently, in 2010–11, she had a solo show at the National Gallery in London.

▷ *Fall* **p.157**

P
Q
R

Mark Rothko

b. 1903 Daugavpils, Latvia
d. 1970 New York, USA

Born in Russia as Marcus Rothkowitz, Mark Rothko immigrated to the United States in 1913, where he later changed his name. He went to Yale University in 1921 but dropped out and moved to New York to study at the Art Students League. In 1935 he cofounded the artists' collective, The Ten. From 1947 onward he began to develop his distinctive style of large rectangular expanses of color. In 1961 he was given a retrospective at New York's Museum of Modern Art. Three years later he accepted a mural commission for a chapel in Houston, Texas; after he committed suicide, the chapel was named after him.

≫ *Rothko Chapel* **p.191**

Sir Peter Paul Rubens

b. 1577 Siegen, Westphalia, Germany
d. 1640 Antwerp, Belgium

Flemish artist Sir Peter Paul Rubens was internationally famous in his lifetime as a painter, scholar, and diplomat, and both King Charles I of England and King Philip IV of Spain were his patrons. Rubens studied painting in Antwerp and became an independent artist at age twenty-two. In 1600 he went to Italy and entered the service of Vincenzo Gonzaga, Duke of Mantua. Rubens returned to Antwerp eight years later and completed a number of high-profile commissions, including two altarpieces for Antwerp Cathedral. In the early 1630s, Charles I commissioned him to paint the ceiling of the Banqueting House in London.

≫ *Minerva Protects Pax from Mars (Peace and War)* **p.143**

Sassetta

a. 1423
d. 1450 Siena, Tuscany, Italy

Born Stefano di Giovanni, the name "Sassetta" was not used until the eighteenth century. Known for his rich coloring, elegant line, and use of spatial relationships, Sassetta is thought to have studied in the workshop of Benedetto di Bindo. Influenced by the international gothic style and the work of Florentine Early Renaissance painters, he developed his own lyrical style. His first documented work is an altarpiece for the Arte della Lana (Guild of Wool Merchants) completed in 1426, and his masterpiece is the double-sided altarpiece for the church of San Francesco at Borgo San Sepolcro (1437–44).

≫ *Mystic Marriage of St. Francis* **p.59**

Egon Schiele

b. 1890 Tulln, Austria
d. 1918 Vienna, Austria

Egon Schiele was admitted to Vienna's Akademie der Bildenden Künste (Academy of Fine Arts) at just sixteen years old but left to form the Neukunstgruppe (New Art Group). He was a friend of painter Gustav Klimt and took Klimt's expressive line further to describe angst-ridden bodies. Schiele's sexually honest subject matter was seen as shocking at the time, and in 1912 he was imprisoned briefly for indecency. When World War I broke out, he joined the army, but by 1917 he was back painting in Vienna. In 1918, Schiele found success at the Vienna Secession, but he died that year, a victim of the flu pandemic.

≫ *Reclining Woman With Green Stockings* **p.103**

Georges-Pierre Seurat

b. 1859 Paris, France
d. 1891 Paris, France

Georges-Pierre Seurat entered the Ecole des Beaux-Arts in 1878. Uninspired, he began to study the color theories of scientist Michel Eugène Chevreul, which explored the understanding of optical effects and perception, and the emotional significance of color. His first large-scale painting, *Bathers at Asnières* (1883–84), reflects his application of color theories and painstaking pointillist technique. The piece was rejected by the Paris Salon in 1884 but was hung at the Salon des Indépendants. Toward the end of his life he concentrated on coastal settings and scenes of entertainment.

≫ *Bathers at Asnières* **p.135**

Jacopo Tintoretto

b. c.1518 Venice, Italy
d. 1594 Venice, Italy

The son of a dyer, Jacopo Comin (also known as Jacopo Robusti) became known by his nickname "Tintoretto" (little dyer). Tintoretto was a native of Venice and rarely left the city, painting almost exclusively for local patrons. In 1562 he was commissioned to produce three large paintings for the Scuola Grande di San Marco. A couple of years later, he won the most ambitious commission of his career, a series of large paintings for the Scuola Grande di San Rocco, which he worked on until 1588 and which chart the development of his style toward a looser, rougher finish and more summary treatment of landscape.

≫ *The Origin of the Milky Way* **p.181**

R
S
T

Titian

b. c.1485–90 Pieve di Cadore, Belluno,
 Veneto, Italy
d. 1576 Venice, Italy

Tiziano Vecellio, known as "Titian,"
studied in Venice under painter
Giovanni Bellini. Titian received his
first important commission in 1510,
producing a series of frescoes for
the Scuola del Santo in Padua.
His reputation burgeoned with a
series of independent commissions,
culminating in the enormous success
of his first public commission in
Venice, an altarpiece for the Church
of Santa Maria Gloriosa dei Frari. The
ensuing years saw Titian become
the leading Venetian artist, and he
was equally inventive in allegorical,
devotional, and mythological painting,
as well as portraiture.

⬚ *The Virgin Suckling the Infant Christ* **p.129**

J. M. W. Turner

b. 1775 London, England
d. 1851 London, England

Joseph Mallord William Turner first
worked as an architect's assistant. In
1789 he was admitted to the Royal
Academy Schools and emulated the
"grand style" it promoted. He exhibited
his first oil painting, *Fishermen at
Sea*, in 1796, and was elected a full
member in 1802. Turner traveled
throughout Europe on sketching
tours for fresh visual material as he
depicted the naturalistic effects of
weather, water, and light. By 1845,
declining health halted his travels but
he became acting president of the
Royal Academy the same year.

⬚ *Sun Setting Over a Lake* **p.21**
⬚ *Van Tromp Going About to Please His
 Masters—Ships a Sea Getting a Good
 Wetting* **p.147**

Paolo Uccello

b. c.1397 Florence, Italy
d. 1475 Florence, Italy

Born Paolo di Dono, Paolo Uccello
worked in the workshop of sculptor
Lorenzo Ghiberti, designer of the
bronze doors for the baptistery of
Florence Cathedral. Uccello spent most
of his life in Florence, but he worked as
a mosaicist in Venice for a few years,
beginning in 1425. In the early 1430s
he made decorative frescoes for the
church of Santa Maria Novella before
turning to the pioneering perspective
ideas of the time. His three *Battle of
San Romano* (c.1435–55) pictures
feature a planned perspectival
scheme and are emblematic of the
contemporary fusion of gothic and
Renaissance styles.

⬚ *Miracle of the Profaned Host* **p.61**

Paolo Veronese

b. c.1528 Verona, Italy
d. 1588 Venice, Italy

Paolo Caliari took the name "Veronese" from Verona, the city in which he was born and where he trained as a young artist. He had settled in Venice by 1553 and, known as a superb colorist, soon became highly sought after as a painter of large-scale decorative frescoes and portraits. Some of his largest projects were theatrical frescoes for the grand villas on the Venetian mainland, owned by the cultured elite who liked the idea of re-creating the splendors of the classical age in their private palaces. For monasteries, he painted a series of large biblical feasts to decorate the walls of their refectories.

≫ *The Wedding Feast at Cana* **p.65**

Leonardo da Vinci

b. 1452 Vinci, Tuscany, Italy
d. 1519 Amboise, Indre-et-Loire, France

Leonardo di ser Piero da Vinci's name comes from the Tuscan town where he was born. He was apprenticed to sculptor Andrea del Verrocchio and by the late 1470s was working as an artist in Florence. In 1482, Leonardo headed for Milan, where he worked at Duke Ludovico Sforza's court and produced *The Last Supper* (1495–98). In the early 1500s, Leonardo was based in Florence and began the *Mona Lisa* (c.1502). In 1508 the artist went to Milan to act as architectural and engineering consultant to King Louis XII. He left Italy for France in 1516 to become King Francis I's chief artist and engineer.

≫ *Mona Lisa* **p.39**
≫ *The Last Supper* **p.77**

Andy Warhol

b. 1928 Forest City, Pennsylvania, USA
d. 1987 New York, USA

Born Andrew Warhola to a working-class immigrant family, Andy Warhol trained as a commercial artist at the Carnegie Institute of Technology. In 1949 he moved to New York, where he became a successful illustrator. He began experimenting with painting and in 1962 held his first fine art exhibition, showing thirty-two canvases of Campbell's soup cans. He became identified with the pop art movement and adopted silk-screen printing. In 1962, Warhol established a studio in Manhattan dubbed the "Factory"; it became a center for the avant-garde, and a year later he started making experimental films.

≫ *Campbell's Soup Cans* **p.189**

T
U
V
W
X
Y
Z

TIMELINE

Cave Painting, Bull and Horses (c.14,000BC)

Tutankhamun is Welcomed by Osiris

Plaster Head of an Old Woman

The Warrior's Leave-taking

The Elgin Marbles

Theatrical Masks of Tragedy and Comedy

Villa dei Misteri

Venus de Milo

Mummy Portrait of a Woman

Laocoön and His Sons

1000 BCE

500 BCE

0

Sculptural Figures on Kandariya Mahadeva Temple

The Road to Calvary

Bayeux Tapestry

500

1000

The Virgin and Child

The Holy Trinity

Mystic Marriage of St. Francis

Miracle of the Profaned Host

The Birth of Venus

The Flagellation of Christ

The Lamentation Over the Dead Christ

The Mond Crucifixion

The Last Supper

Self-Portrait at 13

Mona Lisa

The Creation of Adam

The Dying Slave

Isenheim Altarpiece

The Wedding Feast at Cana

Lamentation of the Death of Christ

1500

The Virgin Suckling the Infant Christ

The Origin of the Milky Way

Martyrdom of St. Erasmus

Minerva Protects Pax from Mars

The Ecstasy of St. Teresa

The Holy Family With the Infant St. John the Baptist and St. Elizabeth

Self Portrait at the Age of 63

1600

1700

Lady Worsley

Artisans Making a Woodcut

Mr. and Mrs. Andrews

Still Life With Jar of Olives

Madame de Senonnes

The Dream of the Fisherman's Wife

Study of the Trunk of an Elm Tree

1800

The Third of May, 1808

La Grande Odalisque

The Raft of the Medusa

Van Tromp Going About to Please His Masters

The Sleepers

Sun Setting Over a Lake

Still Life With Apples

Bathers at Asnières

The Scream

Nevermore O Tahiti

Impression: Sunrise

The Man With the Puffy Face

After the Bath, Woman Drying Herself

Les Demoiselles d'Avignon

I and the Village

Nude Descending a Staircase, No. 2

Reclining Woman With Green Stockings

Counter-Composition of Dissonances, XVI

Wheat Field With Crows

1900

Boats in the Harbor at Collioure

Bathers With a Turtle

Danaë

Large Reclining Nude

Recumbent Figure

Mural

Good Friday, Daisy Nook

Composition No. 6

Nighthawks

Studio V

Study for Homage to the Square

Campbell's Soup Cans

Annette in the Studio

Fall

Rothko Chapel

Be I (Second Version)

Guernica

Study After Velázquez's
Portrait of Pope Innocent X

EXPRESSION BEAUTY NARRATIVE DRAMA EROTIC REALISM FORM MOVEMENT DISTORTION SYMBOLISM

GALLERIES

AGYPTISCHES MUSEUM UND PAPYRUSSAMMLUNG, BERLIN, GERMANY
www.egyptian-museum-berlin.com

Plaster Head of an Old Woman
c.1370–50 BCE
Workshop of Thutmose
⏵ REALISM

APOSTOLIC PALACE, VATICAN CITY
www.vatican.va

The Creation of Adam 1508–12
Michelangelo
⏵ DRAMA

ART INSTITUTE OF CHICAGO, ILLINOIS, USA
www.artic.edu/aic

Artisans Making a Woodcut c.1803
Utamaro Kitagawa
⏵ MOVEMENT

Nighthawks 1942
Edward Hopper
⏵ REALISM

BALTIMORE MUSEUM OF ART, MARYLAND, USA
www.artbma.org

Large Reclining Nude (The Pink Nude) 1935
Henri Matisse
⏵ DISTORTION

BRITISH LIBRARY, LONDON, UK
www.bl.uk

The Dream of the Fisherman's Wife 1814
Hokusai Katsushika
⏵ EROTIC

BRITISH MUSEUM, LONDON, UK
www.britishmuseum.org

The Elgin Marbles from the Parthenon
447–432 BCE
⏵ NARRATIVE

CAPPELLA DEGLI SCROVEGNI, PADUA, ITALY
www.cappelladegliscrovegni.it

Lamentation of the Death of Christ c.1304–13
Giotto di Bondone
⏵ EXPRESSION

The Road to Calvary c.1304–13
Giotto di Bondone
⏵ DRAMA

CENTRE GUILLAUME LE CONQUÉRANT, BAYEUX, FRANCE
www.chateau-guillaume-leconquerant.fr

Bayeux Tapestry 1066–77
⏵ NARRATIVE

THE COURTAULD GALLERY, LONDON, UK
www.courtauld.ac.uk

Nevermore O Tahiti 1897 **Paul Gauguin**
⏵ SYMBOLISM

DES MOINES ART CENTER, IOWA, USA
www.desmoinesartcenter.org

Study After Velázquez's Portrait of Pope Innocent X 1953 **Francis Bacon**
⏵ EXPRESSION

DETROIT INSTITUTE OF ARTS, MICHIGAN, USA
www.dia.org

Be I (Second Version) 1970
Barnett Newman
⊠ SYMBOLISM

FOGG ART MUSEUM, HARVARD UNIVERSITY ART MUSEUMS, USA
www.harvardartmuseums.org

The Holy Family With the Infant St. John the Baptist and St. Elizabeth 1650–51
Nicolas Poussin
⊠ FORM

GALERIE WÜRTHLE, VIENNA, AUSTRIA

Danaë 1907 **Gustav Klimt**
⊠ EROTIC

GALLERIA DEGLI UFFIZI, FLORENCE, ITALY
www.uffizi.com

The Birth of Venus c.1486
Sandro Botticelli
⊠ NARRATIVE

GALLERIA NAZIONALE DELLE MARCHE, PALAZZO DUCALE, URBINO, ITALY
www.palazzoducaleurbino.it

Miracle of the Profaned Host 1465–69
Paolo Uccello
⊠ NARRATIVE

The Flagellation of Christ c.1454
Piero della Francesca
⊠ FORM

GEMEENTE MUSEUM DEN HAAG, THE HAGUE, NETHERLANDS
www.gemeentemuseum.nl

Counter-Composition of Dissonances, XVI 1925 **Theo van Doesburg**
⊠ FORM

GOVERNMENT COLLECTION, LONDON, UK
www.gac.culture.gov.uk

Good Friday, Daisy Nook 1946 **L. S. Lowry**
⊠ MOVEMENT

GRAPHISCHE SAMMLUNG ALBERTINA, VIENNA, AUSTRIA
www.albertina.at

Self-Portrait at Thirteen 1484 **Albrecht Dürer**
⊠ BEAUTY

HAMBURGER KUNSTHALLE, HAMBURG, GERMANY
www.hamburger-kunsthalle.de

Annette in the Studio 1961 **Alberto Giacometti**
⊠ DISTORTION

HAREWOOD HOUSE, YORKSHIRE, UK
www.harewood.org

Lady Worsley c.1776 **Sir Joshua Reynolds**
⊠ DISTORTION

J. PAUL GETTY MUSEUM, LOS ANGELES, CALIFORNIA, USA
www.getty.edu/museum

Mummy Portrait of a Woman c.100–110
Isidora Master
⊠ REALISM

Van Tromp Going About to Please His Masters—Ships a Sea Getting a Good Wetting 1844 **J. M. W. Turner**
⊠ MOVEMENT

KANDARIYA MAHADEVA TEMPLE, KHAJURAHO, MADHYA PRADESH, INDIA

Sculptural Figures c.1000 **Hindu artists**
⊠ EROTIC

LASCAUX CAVES, DORDOGNE, FRANCE
www.lascaux.culture.fr

Cave Painting, Bull and Horses c.14,000 BCE
Lascaux artists
⊠ REALISM

MUSÉE CONDE, CHANTILLY, FRANCE
www.musee-conde.fr

Mystic Marriage of St. Francis 1437–44
Sassetta
⊠ NARRATIVE

MUSÉE DES BEAUX-ARTS, NANTES, FRANCE
www.nantes.fr/site/mba/lang/en/Accueil

Madame de Senonnes 1814
Jean-Auguste-Dominique Ingres
⊠ DISTORTION

MUSÉE DU LOUVRE, PARIS, FRANCE
www.louvre.fr

La Grand Odalisque 1814
Jean-Auguste-Dominque Ingres
⊠ BEAUTY

Mona Lisa 1503–06 **Leonardo da Vinci**
▷ BEAUTY

Still Life With Jar of Olives 1760
Jean-Siméon Chardin
▷ BEAUTY

The Dying Slave 1513–16 **Michelangelo**
▷ EROTIC

The Raft of the Medusa 1819
Théodore Géricault
▷ DRAMA

The Wedding Feast at Cana 1562–63
Paolo Veronese
▷ NARRATIVE

Venus de Milo c.130–100 BCE
▷ BEAUTY

**MUSÉE MARMOTTAN MONET,
PARIS, FRANCE**
www.marmottan.com

Impression: Sunrise 1872 **Claude Monet**
▷ BEAUTY

MUSÉE DU PETIT PALAIS, PARIS, FRANCE
www.petitpalais.paris.fr

The Sleepers 1866 **Gustave Courbet**
▷ EROTIC

**MUSÉE D'UNTERLINDEN,
COLMAR, FRANCE**
www.musee-unterlinden.com

Crucifixion, from the Isenheim Altarpiece
1512–16 **Mathis Grünewald**
▷ EXPRESSION

MUSEI CAPITOLINI, ROME, ITALY
en.museicapitolini.org

*Theatrical Masks of Tragedy
and Comedy* c.200 BCE
▷ DRAMA

MUSEO REINA SOFÍA, MADRID, SPAIN
www.museoreinasofia.es

Guernica 1937 **Pablo Picasso**
▷ EXPRESSION

MUSEO DEL PRADO, MADRID, SPAIN
www.museodelprado.es

The Third of May, 1808 1814 **Francisco de Goya**
▷ DRAMA

**MUSEUM OF MODERN ART,
NEW YORK, USA**
www.moma.org

Campbell's Soup Cans 1962 **Andy Warhol**
▷ SYMBOLISM

I and the Village 1911 **Marc Chagall**
▷ SYMBOLISM

Les Demoiselles d'Avignon 1907
Pablo Picasso
▷ DISTORTION

Studio V 1949–50 **Georges Braque**
▷ FORM

NASJONALGALLERIET, OSLO, NORWAY
www.nasjonalmuseet.no

The Scream 1893 **Edvard Munch**
▷ SYMBOLISM

NATIONAL GALLERY, LONDON, UK
www.nationalgallery.org.uk

After the Bath, Woman Drying Herself 1890–95
Edgar Degas
▷ MOVEMENT

Bathers at Asnières 1884
Georges-Pierre Seurat
▷ FORM

*Minerva Protects Pax from Mars (Peace
and War)* 1629–30 **Sir Peter Paul Rubens**
▷ MOVEMENT

Mr. and Mrs. Andrews c.1750
Thomas Gainsborough
▷ NARRATIVE

Self-Portrait at the Age of 63 1669
Rembrandt van Rijn
▷ REALISM

The Mond Crucifixion 1502–03 **Raphael**
▷ SYMBOLISM

The Origin of the Milky Way c.1575
Jacopo Tintoretto
▷ SYMBOLISM

The Virgin and Child 1426 **Masaccio**
▷ FORM

The Virgin Suckling the Infant Christ
c.1570–76 **Titian** ▷ FORM

**PHILADELPHIA MUSEUM
OF ART, PENNSYLVANIA, USA**
www.philamuseum.org

Nude Descending a Staircase, No.2 1912
Marcel Duchamp
▷ MOVEMENT

PINACOTECA DI BRERA, MILAN, ITALY
www.brera.beniculturali.it

The Lamentation Over the Dead Christ c.1480
Andrea Mantegna
⊠ DISTORTION

ROTHKO CHAPEL, HOUSTON, TEXAS, USA
www.rothkochapel.org

Rothko Chapel 1964–70 **Mark Rothko**
⊠ SYMBOLISM

**ROYAL ACADEMY OF ARTS,
LONDON, UK**
www.royalacademy.org.uk

Boats in the Harbor at Collioure 1905
André Derain
⊠ EXPRESSION

**SAINT LOUIS ART MUSEUM,
MISSOURI, USA**
www.slam.org

Bathers With a Turtle 1908 **Henri Matisse**
⊠ DRAMA

**SANTA MARIA DELLE GRAZIE,
MILAN, ITALY**

The Last Supper 1495–98 **Leonardo da Vinci**
⊠ DRAMA

**SANTA MARIA DELLA VITTORIA,
ROME, ITALY**
www.chiesasmariavittoria.191.it

The Ecstasy of St. Teresa 1645–52
Gianlorenzo Bernini
⊠ EROTIC

**SANTA MARIA NOVELLA,
FLORENCE, ITALY**
www.museumsinflorence.com/musei/santa_
maria_novella-cloist.html

The Holy Trinity 1425–26 **Masaccio**
⊠ REALISM

**STAATLICHE ANTIKENSAMMLUNGEN UND
GLYPTOTHEK, MUNICH, GERMANY**
www.antike-am-koenigsplatz.mwn.de

The Warrior's Leave-taking c.500 BCE
Euthymides
⊠ REALISM

**STATE HERMITAGE MUSEUM,
ST. PETERSBURG, RUSSIA**
www.hermitagemuseum.org

Composition No. 6 1913 **Wassily Kandinsky**
⊠ EXPRESSION

**TATE COLLECTION,
LONDON, UK**
www.tate.org.uk/collection

Fall 1963 **Bridget Riley**
⊠ MOVEMENT

Recumbent Figure 1938 **Henry Moore**
⊠ DISTORTION

Sun Setting Over a Lake c.1840
J. M. W. Turner
⊠ EXPRESSION

**UNIVERSITY OF IOWA MUSEUM
OF ART, IOWA, USA**
uima.uiowa.edu

Mural 1943 **Jackson Pollock**
⊠ MOVEMENT

**VAN GOGH MUSEUM, AMSTERDAM,
NETHERLANDS**
www.vangoghmuseum.nl

The Man With the Puffy Face 1889
Vincent van Gogh
⊠ BEAUTY

Wheat Field With Crows 1890
Vincent van Gogh
⊠ EXPRESSION

**VATICAN MUSEUMS AND GALLERIES,
VATICAN CITY**
www.vatican.va

Laocoön and His Sons c.25 BCE
Hagesandros, Athenodoros, Polydorus
⊠ DRAMA

Martyrdom of St. Erasmus 1628–29
Nicolas Poussin
⊠ BEAUTY

**VICTORIA & ALBERT MUSEUM,
LONDON, UK**
www.vam.ac.uk

Study of the Trunk of an Elm Tree c.1821
John Constable
⊠ REALISM

VILLA DEI MISTERI, POMPEII, ITALY

Scourged Woman and Dancer With Cymbals
70–60 BCE **Campanian artist**
⊠ EROTIC

INDEX

Bold type refers to illustrations

AUTHORS

ANDY PANKHURST studied at the Slade School of Fine Art in London. A deeply expressive figurative painter, his work is represented in various collections and museums in the UK and the USA. He teaches at the Prince's Drawing School and at the National Portrait Gallery in London. In 2002 he cofounded the London School of Painting and Drawing.

Andy Pankhurst would like to dedicate this book in memory of Howard Brown.

LUCINDA HAWKSLEY is the author of more than twenty books, including the biographies *Lizzie Siddal: The Tragedy of a Pre-Raphaelite Supermodel* and *Katey: The Life and Loves of Dickens's Artist Daughter*. Lucinda is also an award-winning travel writer and a regular lecturer at I.E.S. London and at the National Portrait Gallery in London.

Lucinda Hawksley would like to dedicate this book to Sarah, Archie, and John.